5
5

IMAGE

GLOUCESTER MASSACHUSETTS

ROCKPORT
PUBLISHERS

TAL PORTFOLIO

First published in the United States of America by

Rockport Publishers, Inc.
33 Commercial Street
Gloucester, Massachusetts 01930-5089
Telephone: (978) 282-9590
Facsimile: (978) 283-2742

www.rockpub.com

ISBN 1-56496-467-1

10 9 8 7 6 5 4 3 2 1

Design: Chen Design Associates, SF

Printed in China.

741.66GRA
329322

Thanks to my family, and especially Brad. You are my creative inspiration.

IF YOU THINK ABOUT IT, THERE PROBABLY ISN'T ANY
SINGLE INDUSTRY THAT HAS BEEN MORE INFLUENCED
BY THE ADVANCEMENT IN COMPUTER TECHNOLOGY AND
DIGITAL REPROGRAPHIC SYSTEMS THAN THE GRAPHIC
DESIGN FIELD. As a result, web sites, Zip drives, and CD-ROMs are swiftly replacing the
traditional black portfolio for designers looking to impress their next client.
THIS IS HARDLY SURPRISING, SINCE VIRTUALLY EVERY
DESIGNER USES A COMPUTER FOR PREPRESS, TYPESET-
TING, AND DESIGN. IT'S ONLY FITTING THEN, THAT DIGITAL
PORTFOLIOS HAVE MADE THEIR WAY TO THE FOREFRONT
OF DESIGN PRESENTATION.

NOW IT'S NOT NECESSARY TO LUG THAT TI
NO LONGER IS IT ESSENTIAL TO ENTRUST F
ORIGINALS, WHICH HAD THE POTENTIAL TO
PASSING THROUGH SEVERAL HANDS BEFO

Today a digital portfolio is the hot ticket for displaying design work. Unlike
hard-copy portfolios, digital portfolios provide an immediate and highly tech-
nical forum to showcase unique talents and capabilities, using cutting edge
graphic design techniques. Animation and simulated 3-D environments allow
potential clients to view work in ways not possible with a traditional portfo-
lio. Digital portfolios can be altered and updated easily, as new design work
is cranked out. What's more, portfolios on Zip disks or CD-ROMs are easy to
duplicate and inexpensive to ship to potential clients.

IMAGE

**CK, BLACK SUITCASE ALL AROUND TOWN.
OSPECTIVE CLIENTS WITH IRREPLACEABLE
GET LOST, DAMAGED, OR STOLEN WHILE
BEING RETURNED.**

INTRO

WEB PORTFOLIOS ARE EQUALLY EFFECTIVE, ALLOWING
POTENTIAL CLIENTS TO BROWSE AT THEIR LEISURE AND
RETURN TIME AND TIME AGAIN. IN FACT, THE WEB HAS
ACTED AS THE GREAT EQUALIZER, MAKING THE PLAYING
FIELD MORE EVEN FOR DESIGNERS ALL OVER THE WORLD.

YET THE INCREASED USAGE OF A DIGITAL FORMAT FOR PORTFOLIOS CREATES UNIQUE CIRCUMSTANCES. SOME DESIGN PIECES LEND THEMSELVES BETTER TO PRINT RATHER THAN PIXEL. FINDING AN ADEQUATE METHOD TO EXHIBIT SUCH PIECES IN A DIGITAL FORMAT IS A CHALLENGE. SIZE RESTRICTIONS AND INFINITE SPACE CAN ALSO THROW ONE FOR A LOOP. SINCE FILES MUST BE LOW-RESOLUTION FOR DIGITIZING, IMAGES TEND TO BE SMALLER THAN THE ACTUAL PIECE. AND HAVING AN INFINITE AMOUNT OF SPACE AVAILABLE CAN CAUSE OVERKILL. SOMETIMES MORE BANG ISN'T BETTER, ESPECIALLY IF POTENTIAL CLIENTS HAVE TO STRUGGLE THROUGH A LABYRINTH.

And then there's always the "Wow" factor. We all know the two-second rule of thumb. As potential clients become more savvy about digital design capabilities, the "Wow" factor will become increasingly important. What better medium than a digital portfolio to exhibit technological prowess?

MAKING THE DIGITAL PORTFOLIO USER-FRIENDLY IS KEY. A LIVELY PRESENTATION AND EASY NAVIGATION ARE ESSENTIAL. GUIDING THE VIEWER FROM DESIGN PIECE TO DESIGN PIECE WITHOUT INTERJECTING A LOT OF IMAGES HELPS KEEP THE VIEWER FOCUSED. KEEPING PRESENTATIONS QUICK AND SIMPLE WILL PREVENT THE VIEWER FROM GETTING DISTRACTED.

FINALLY, AT ISSUE IS THE EMOTIONALLY CHARGED MATTER OF COPYRIGHT ABUSE OF THE WORK CONTAINED IN A DIGITAL PORTFOLIO AS WELL AS THE ACTUAL DESIGN STRUCTURE OF THE PORTFOLIO. IT'S NO SECRET THAT DISPLAYING WORK IN A DIGITAL FORMAT COMPROMISES OWN-ERSHIP RIGHTS TO INTELLECTUAL AND CREATIVE PROPERTY.

STILL, DESPITE A FEW CHALLENGES, THE BENEFITS OF HAVING A DIGITAL PORTFOLIO ARE STRIKINGLY CLEAR. DIGITAL PORTFOLIOS NOT ONLY ALLOW DESIGNERS TO FEATURE MORE WORK IN LESS SPACE, THEY ARE EASIER TO TRANSPORT, LESS EXPENSIVE TO PRODUCE, AND SIMPLY A MUST FOR ANY UP-AND-COMING DESIGNER WORKING IN DIGITAL MEDIA.

GETTING THE MOST OUT OF YOUR DOTS PER INCH

IT'S SOMEWHAT IRONIC THAT THE COMPUTER HAS REVOLU-TIONIZED THE WORLD OF GRAPHIC DESIGN, ALLOWING FOR DIGITAL MANIPULATION OF IMAGES, PHOTOGRAPHS, AND DESIGN ELEMENTS. YET WHEN IT COMES TO DISPLAYING DIG-ITIZED WORK IN A DIGITAL PORTFOLIO, THIS MAGNIFICENT MEDIA THROWS A FEW CURVES IN THE ROAD. REDUCING A PRINT PIECE TO A SUITABLE SIZE FOR DOWNLOADING HAS ITS CHALLENGES. RESOLUTION SUFFERS. COLOR LACKS PUNCH. TOSS IN THE LACK OF THE TACTILE, AND IT'S REALLY UNSETTLING. REMEMBER YOU ARE NOT ALONE. EVERY TECHNO-SAVVY DESIGNER IS FACED WITH THE SAME CHAL-LENGES. SO, THE PLAYING FIELD IS EQUAL, FOR ONCE.

FOR A DIGITAL PORTFOLIO, THE GENERAL CONSENSUS IS THAT PRINT AND PACKAGING LOOKS FLAT AND LOSES A LOT OF TEXTURE. PIECES SUCH AS ANNUAL REPORTS, WITH MANY DIFFERENT PAPER STOCKS, LOSE DETAILS AND CAN LOOK UNIMPRESSIVE IN A DIGITAL PORTFOLIO. AS RULE OF THUMB, VERY BUSY, COMPLEX VISUALS DO NOT WORK WELL IN A PIXEL FORMAT. SIMPLE AND CLEAN DESIGN WORK IS THE BEST BET.

WHEN YOU GO FROM PIXEL TO PRINT AND BACK TO PIXEL AGAIN, SOMETHING HAS TO BE LOST ALONG THE WAY. RESOLUTION ISSUES ARE OBVIOUSLY A PROBLEM. HIGH RESOLUTION AND THE WEB SIMPLY DON'T MESH. CONVERTING HIGH-RESOLUTION FILES TO LOW RESOLUTION CAN BE TIME-CONSUMING. THE NEED TO COMPRESS FILES FOR TRANSMITTING VIA A MODEM OR FOR STORAGE ON A CD-ROM OR ZIP DISK IS APPARENT. BUT COMPRESSED IMAGES TEND TO HAVE FEWER COLORS, ARE NOT QUITE AS SHARP, LACK TINY DETAIL, AND DON'T QUITE COMPARE TO UNCOMPRESSED IMAGES. SINCE THE IMAGES ARE BITMAPPED, THE LIMITED, FLAT TEXTURES OF A TWO-DIMENSIONAL PRINT CAN LOOK QUITE UNIMPRESSIVE ON SCREEN. FORTUNATELY, COMPUTERS HAVE REACHED THE MAINSTREAM. PEOPLE ARE ACCUSTOMED TO SEE-ING BITMAPPED IMAGES ON A COMPUTER SCREEN. KEEP IN MIND THAT THE INTENT WITH A DIGITAL PORTFOLIO IS TO CONVEY A FEELING OF A PARTICULAR PIECE. IF THE DESIGN IS SAVVY (WHICH IT OUGHT TO BE IF IT'S IN YOUR PORTFOLIO!), THEN WHAT'S THE WORRY?

PRINT

WHEN IT COMES TO COLOR, WHAT YOU SEE ISN'T ALWAYS WHAT YOU GET. SINCE THE COLORS ON YOUR MONITOR ARE CREATED WITH TRANSMITTED LIGHT, WHILE THE COLORS IN A PRINTED PIECE COME FROM REFLECTED LIGHT, TRYING TO MATCH COLORS IS OUT OF THE QUESTION. THE PECULIARITIES OF EACH INDIVIDUAL MONITOR COMPOUND THE SITUATION. NO TWO SCREENS ARE ALIKE. IT'S NO SECRET THAT PIXEL DRA-MATICALLY LIMITS THE COLOR PALETTE. MOST DESIGN-ERS COMPENSATE FOR THIS BY USING WEB-SAFE COL-ORS, WHICH ARE TAKEN FROM THE COLOR LOOK UP TABLE BROWSER (CLUT), IN THE DESIGN OF THEIR DIGI-TAL PORTFOLIOS. BUT THERE ARE ONLY 216 COLORS INCLUDED IN THE CLUT BROWSER. RECREATING A PIECE IN WEB-SAFE COLORS IS TIME-CONSUMING, AND YOU NEVER REALLY KNOW HOW IT WILL LOOK ON THE VIEW-ER'S MONITOR ANYWAY. THEREFORE, USING WEB-SAFE COLORS FROM THE START SEEMS TO MAKE SENSE.

A typical high-resolution image can eat up anywhere from 10 to 90 megabytes or more. Yet just try taking a 13MB file and distilling it into your online portfolio. It isn't going to happen.

TO PIXEL

So how do you go about controlling the file size of your online images? Many designers reduce the color requirements and compress the artwork. Two file formats that accomplish these tasks are Graphic Interchange Formats (GIFs) and Joint Photographic Experts Groups (JPEGs), each with their disadvantages. GIFs tend to limit the color palette, whereas JPEGs require compressing artwork but salvage more of the colors. But if you want a potential client with an average modem to be able to view your superb stuff, making it timely and easy for her to download is a high priority. Bells and whistles are nice, but if a viewer experiences a huge time lag downloading fancy images, all that will be lost on him.

A 28.8K modem is still very common with web surfers, so you can assume it will take approximately one-half second per kilobyte to transfer an image. That translates to 30 seconds of downloading time per 60K file. If that were the case, that 13MB file would have taken more than one and a half hours to download!

Okay, it's true; the experience isn't quite the same. But it doesn't have to be a bad experience. Take a pixel format, toss in a few tricks, and the lack of the tactile will seem irrelevant. Here's your chance to show off, strut your stuff. With a pixel format, brochures and cards can be opened with animation. Packaging pieces can be shown in 3-D from various angles. Logos can blink, beat, rotate, gyrate–whatever you want them to do. Now you can't do that with a traditional black portfolio, can you?

RICHARD PUDER DESIGN GROUP

THE CIRCLE GRID WAS DESIGNED AND DEVELOPED TO REPRESENT THE RPD GROUP'S GOAL OF ACHIEVING PERFECT BALANCE. IT ALSO WORKS WELL AS A FOUNDATION FOR DISPLAYING COMPONENTS. BLACK FRAMING ENHANCES EACH PIECE. THE COLOR SELECTION SYMBOLIZES THE FIRM'S CONTINUOUS GROWTH (GREEN) AND THE CONFIDENCE AND COMFORT (BEIGE) OFFERED TO CLIENTS. THE CLASSICAL FONTS WERE CHOSEN TO CONVEY STRENGTH (CF GOTHIC) AND WARMTH (GIL SANS) AND TO SAVE SPACE (CLAREDON).

THE RPD GROUP PORTFOLIO WAS CREATED IN ADOBE ACROBAT'S PDF FORMAT FOR ITS VERSATILITY, INCLUDING DOWN-LOADING EASE, FAST SEARCH NAVIGATION, FULL-COLOR VIEWING, AS WELL AS SELECTIVE VIEWING OF ANY PRINTED WORK RELEVANT TO A CLIENT'S NEEDS.

Richard Puder Design Group's portfolio section can be viewed using Adobe Acrobat Reader. The program can be downloaded from the site.

By placing the mouse over a black dot, the potential client is able to see the type of design work available for viewing. Options include posters, banners, charts, catalogs, educational programs, and product promotions.

The Prentice Hall interactive kit has fourteen
elements and more than fifty pieces. It is designed
for use in Spanish classes for grades 7 through 12.

CLIENT **Prentice Hall**

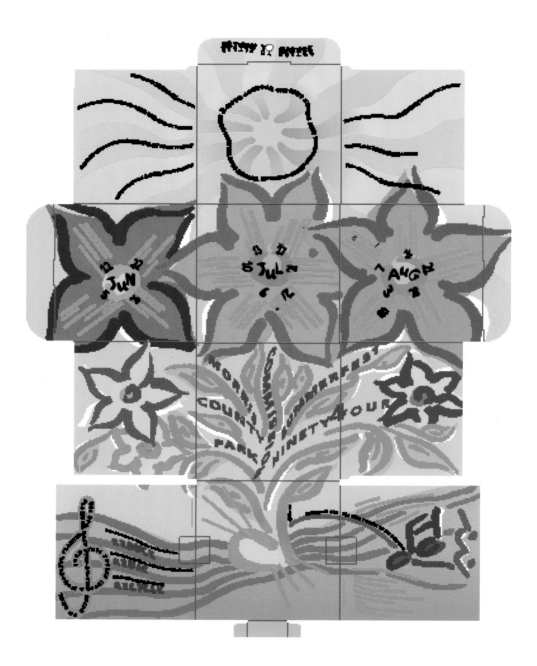

"Reduce, Reuse & Recycle" was the theme for this Morris County Parks Summer Music poster. The interactive poster folds to become a wearable hat.

CLIENT **Morris County Parks**

Scholastic commissioned eighteen banners, designed to initiate interest in its reading program. The bright colors and simple shapes of these two are perfectly compatible for the young age group targeted.

CLIENT **Scholastic**

These examples of 350 charts produced for Silver Burdett & Ginn make optimal use of visuals to ease understanding of data for children.

CLIENT **Silver Burdett & Ginn**

COAL:
FROM MINE TO USER

Coal is loaded on a ship at Hampton Roads to be taken to other states and other countries.

Railroads transport coal from the mine.

Coal is delivered to factories.

Coal is delivered to local companies.

The companies take coal to their customers.

HOW COAL IS FORMED

Plants and trees

Swamp

Plants die and sink into a swamp.

Soil

Peat

Decaying plants compress, harden, and become peat.

New plants and trees

Topsoil
Sandstone
Soil
Shale
Limestone
Shale
Coal

Peat sinks under pressure and forms coal.

THE HIEBING GROUP

THE HIEBING GROUP'S HOME WEB PAGE FEATURES BLACK-AND-WHITE PHOTOGRAPHY THUMBNAILS, REPRESENTATIVE OF THE DIFFERENT SECTIONS OF ITS WEB SITE. THE PORTFOLIO OF BIG IDEAS SECTION IS LISTED FIRST, A MOST SIGNIFICANT PART OF THE SITE. AS AN INTEGRATED MARKETING COMMUNICATIONS FIRM, THE HIEBING GROUP OFFERS A SAMPLER OF A VARIETY OF WORK ACROSS A WIDE RANGE OF MEDIUMS AND MARKETING STRATEGIES WITHIN THE PORTFOLIO SECTION. THE LOOK IS STRONG, CONFIDENT, AND UNDERSTATED. SOME ELEMENTS OF THE CORPORATE IDENTITY ARE RETAINED IN THE PORTFOLIO SECTION, INCLUDING THE COLORS—RED IN THE BORDER AND A BLACK BACKGROUND. HOWEVER, THE INTENT WITH THE PORTFOLIO SECTION WAS TO LET THE WORK TAKE CENTER STAGE, NOT THE CORPORATE IDENTITY. AS A RESULT, THE HIEBING GROUP KEPT THE OVERALL DESIGN OF THE DIGITAL PORTFOLIO SIMPLE AND CLEAN.

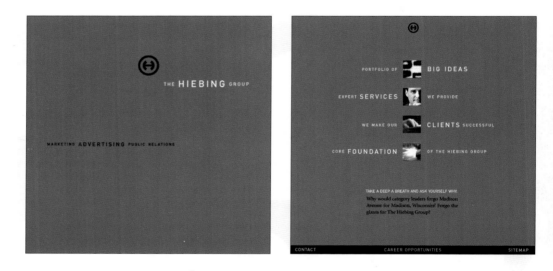

The Hiebing Group's web site design is an extension of its corporate identity, using red and black as the dominant colors.

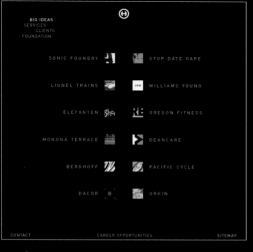

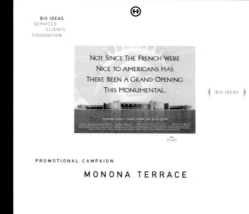

The Portfolio of Big Ideas contains thumbnails of work for various clients. The Hiebing Group's corporate identity has such strength to it that the firm adopted a minimal approach instead for the portfolio section. The background is basic black in order to focus on the work, but the "H" on the top of the page and red border maintain a presence.

When Madison celebrated the opening of the Frank Lloyd Wright-designed Monona Terrace Community and Convention Center, it was a big deal for Wisconsin. The Hiebing Group made it a big deal for the entire country as well. The firm helped plan a big, bold, three-day blowout using television, radio, posters, and other media.

CLIENT **Monona Terrace Community and Convention Center**

zoom

NATIONAL PRINT

DACOR SCUBA GEAR

To become the category leader, you have to
think big. So our campaign for Dacor features
their gear on the world's number one TV
show, in the world's longest underwater cave
and in the world's largest indoor aquarium.
These stories also helped bring expert
testimonials and adventure to the catalog.

‹ BIG IDEAS ›

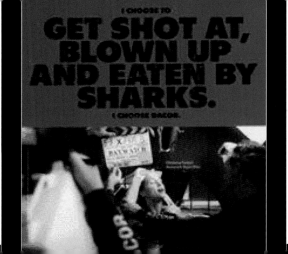

‹ BIG IDEAS ›

CORPORATE BROCHURE

WILLIAMS YOUNG

Accounting firm Williams Young knows
that affairs of business rarely line up in
tidy columns. That's why we dreamed up
this Rorschach-style corporate ID, which
emphasizes the firm's ability to examine
the very recesses of business and
financial possibilities. Tickled pink with
their new tagline, "Think Black Ink," the
client hosted a huge bash to celebrate.
And the ID garnered a bucket of ink in
the business press.

THINK BLACK INK

WILLIAMS YOUNG

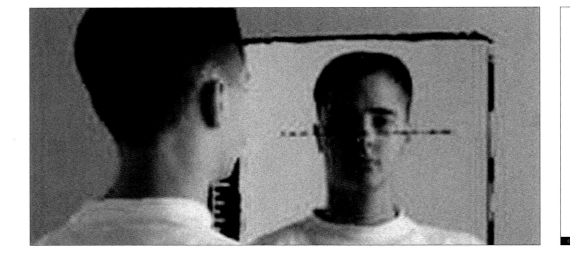

The Wisconsin Coalition Against Sexual Assault public awareness campaign was aimed at preventing teen date rape in Wisconsin. The challenge was in forcing teens to personalize a subject they don't want to think about. The Hiebing Group decided to use a mirror so teens would put themselves in the ad.

CLIENT **Wisconsin Coalition Against Sexual Assault**

EAT MORE COOKIES.

OREGON SPORTS & FITNESS CLUB

I thig I bwoke my nothe!

1-800-57-NURSE

CHOOSE DeanCare

ABOVE: When Oregon Fitness implored viewers to "Eat More Cookies" in its outdoor campaign, people were champing at the bit to open new memberships.

CLIENT **Oregon Fitness**

BELOW: This outdoor campaign for Dean Health Care's special nurse hotline was designed to make patients feel comfortable calling the hotline. The Hiebing Group dramatized very funny, very human situations to put viewers at ease.

CLIENT **Dean Health Care**

THE GRETEMAN GROUP

THE GRETEMAN GROUP CHOSE TO CELEBRATE ITS KANSAS ROOTS BY ADOPTING THE STATE MOTTO AD ASTRA PER ASPERA, MEANING "TO THE STARS THROUGH DIFFICULTY." THE COLORS OF THE OPENING PAGE REFLECT THE WARM GOLDEN TONES OF THE PRAIRIE AND THE MAGNIFICENT PURPLES OF THE SUNSETS. THE FIRM USED A REAL ILLUSTRATION, WHICH REFLECTS ITS WORK MORE ACCURATELY THAN A COMPUTER–DRAWN DIGITIZED IMAGE. THE ANIMATED STARS ON THE HOME PAGE REINFORCE THE THEME AND ADD INTEREST WITHOUT TAKING A LONG TIME TO LOAD. THE SIMPLE BLACK BACKGROUND THROUGHOUT THE SITE FOCUSES THE VIEWER'S ATTENTION ON THE PORTFOLIO PIECES. NAVIGATION IS MADE EASIER BY DISPLAYING THE CURRENT PAGE NUMBER AS WELL AS THE TOTAL NUMBER OF PAGES IN ANY SECTION.

The Greteman Group's home page displays a full-color illustration of a sun with wings above a silhouette. The black background with blue stars gives this site a celestial feel. By clicking on the sun, the viewer opens the index page, which leads to the portfolio section.

The index page leads the viewer to the clearly marked portfolio section. The use of spheres reinforces the celestial feel of the site. To make navigation easy, the headers across the top of every page are color coded to the buttons at the bottom. Each section of the site is a unique color, which helps the viewer know at a glance where she is.

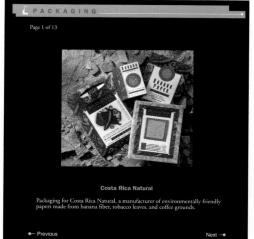

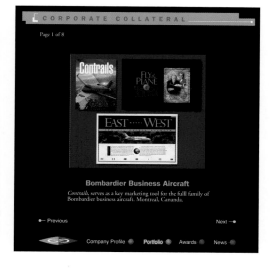

The portfolio section utilizes a circular grid against a black background that highlights various sections including annual reports, direct mail, packaging, corporate identity, multimedia, posters, and signage.

Packaging for Costa Rica Natural, a manufacturer of environmentally friendly papers, is made from banana fiber, tobacco leaves, and coffee grounds.

CLIENT **Costa Rica Natural**
CREATIVE DIRECTOR/ART DIRECTOR **Sonia Greteman**
DESIGNER/ILLUSTRATOR **James Strange**
PRODUCTION ARTIST **Jo Quillin**

Greteman Group designed this promotional magazine for Bombardier, Inc., a manufacturer of airplanes and business jets.

CLIENT **Bombardier, Inc.**
CREATIVE DIRECTOR/ART DIRECTOR **Sonia Greteman**
DESIGNERS **James Strange, Craig Tomson**
PHOTOGRAPHERS **Roger Bain, Paul Bowen, Guillaume Garrigue**
COPYWRITER **Deanna Harms**

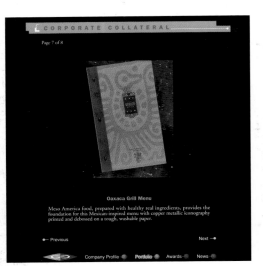

Oaxaca Grill Menu

Meso America food, prepared with healthy real ingredients, provides the foundation for this Mexican-inspired menu with copper metallic iconography printed and debossed on a tough, washable paper.

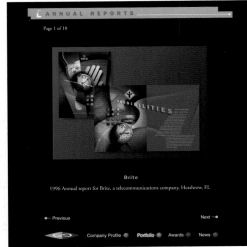

Brite

1996 Annual report for Brite, a telecommunications company, Heathrow, FL.

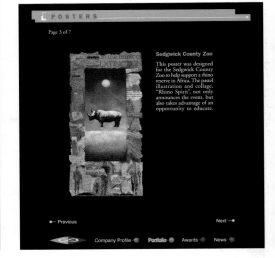

Sedgwick County Zoo

This poster was designed for the Sedgwick County Zoo to help support a rhino reserve in Africa. The pastel illustration and collage, "Rhino Spirit", not only announces the event, but also takes advantage of an opportunity to educate.

Meso American food, prepared with healthy ingredients, provides the foundation for this Mexican-inspired menu with copper metallic iconography, printed and debossed on a tough, washable paper.

CLIENT **Oaxaca Grill**
CREATIVE DIRECTOR/ART DIRECTOR **Sonia Greteman**
DESIGNERS **Craig Tomson, Chris Parks, Jo Quillin**

This annual report was designed for Brite, a telecommunications company in Heathrow, Florida.

CLIENT **Brite**
ART DIRECTORS **Sonia Greteman, James Strange**
DESIGNERS **James Strange, Craig Tomson**
PHOTOGRAPHER **Steve Rasmussen**
COPYWRITER **Deanna Harms**

This poster was designed for the Sedgwick County Zoo to help support a rhino reserve in Africa. The pastel illustration and collage, "Rhino Spirit," not only announces the event but also takes advantage of an opportunity to educate.

CLIENT **Sedgwick County Zoo**
ART DIRECTOR **Sonia Greteman**
DESIGNERS **Sonia Greteman, Jeanette Palcowet**
ILLUSTRATOR **Sonia Greteman**

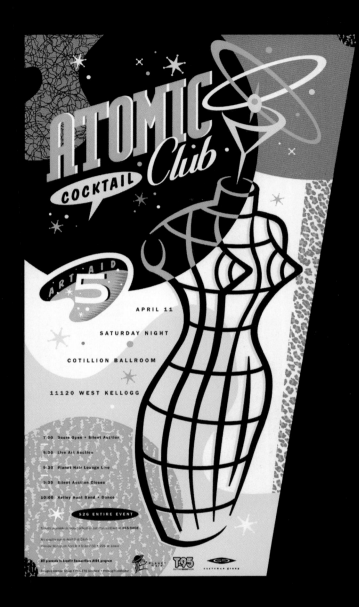

This poster was designed to promote an event that
raised money for ConnectCare, an AIDS awareness
organization. The vibrant colors combined with the
clever illustration make the viewer take notice.

CLIENT **ConnectCare**
CREATIVE DIRECTOR/ART DIRECTOR **Sonia Greteman**
DESIGNERS **Sonia Greteman, James Strange**
COPYWRITER **Todd Gimlin**

JOÃO MACHADO

JOÃO MACHADO, OF JOÃO MACHADO, DESIGN LDA OF PORTUGAL, HAS ESTABLISHED AN INTERNATIONAL REPUTATION AS AN ILLUSTRATOR AND POSTER DESIGNER. MACHADO CHOSE BLUE AS THE PRIMARY COLOR FOR HIS FIRM'S WEB PORTFOLIO. WHILE NOT THE CORPORATE COLOR, IT IS ONE OF MACHADO'S FAVORITES. BLUE IS ALSO SYMBOLIC OF O'PORTO, WHERE THE FIRM IS LOCATED. THE BLACK BACKGROUND ALLOWS FOR LARGE, CLEAR VIEWS OF THE CHOSEN DESIGN PIECES. THE BLUE DOTS RUNNING ACROSS THE PAGE PROVIDE A SENSE OF TEXTURE WITHIN THE SIMPLE DESIGN. WHEN DESIGNING THE WEB PORTFOLIO, MACHADO DECIDED TO TAKE A MINIMALIST APPROACH, BOTH GRAPHICALLY AND STRUCTURALLY. FEATURED IN THE WEB PORTFOLIO ARE FOUR SECTIONS OF DESIGN WORK, INCLUDING POSTERS, STAMPS, LOGOS, AND CATALOGS. THE WEB SITE ALSO INCLUDES INFORMATION ABOUT JOÃO MACHADO AND AN IMPRESSIVE CLIENT LIST.

The portfolio index page has a black background with a blue rectangle in the upper right. Blue dots across the middle of the screen give texture. For the benefit of international clients, the portfolio lists the types of design work in both Spanish and English.

Bright and colorful thumbnails of numerous posters are displayed for review against a black background. For a closer look, the potential client can click on an image to see an enlarged view.

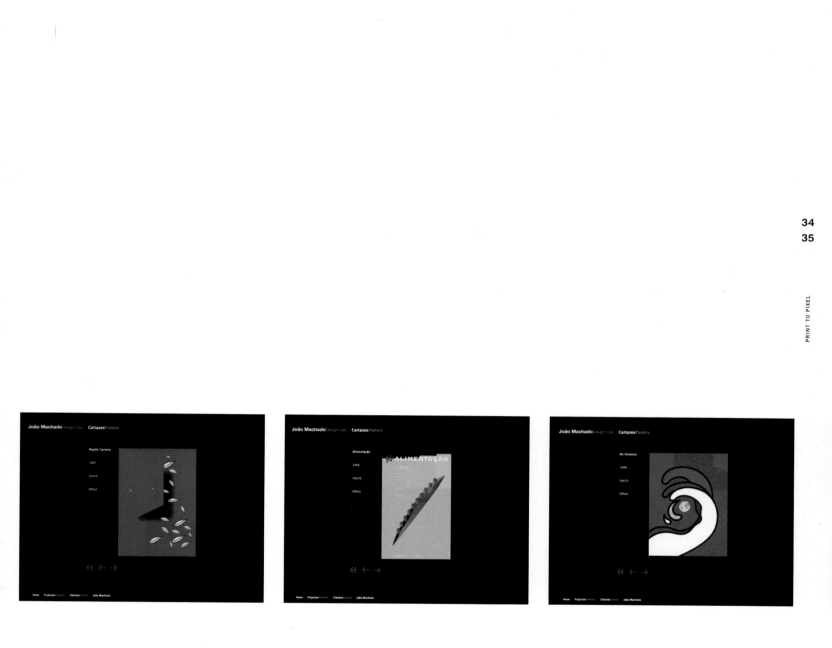

This poster is one of a series of four for a paper company. The illustrations show how sheets of paper may be used in different situations such as stationary, wrapping paper, books, and more. This poster shows the role of paper in a book. The company used these poster illustrations in its annual report.

CLIENT: **Sociedade de Distribuição de Papel**

Exponor organizes international trade fairs and exhibitions. This poster, with a yellow background and green pea pod, was developed for an international food exhibition in 1996.

CLIENT: **Exponor-Feira International do Porto**

This poster was designed for Expo'98, an international environmental exhibition held in Lisbon in 1998. The main subject of the exhibition was the ocean, so it is fitting that the illustration features a big wave. The chosen colors of blue, white, green, red and yellow are naturally linked to the ocean.

CLIENT: **Expo'98**

Jazz Nantes

1996

50x70

Offset

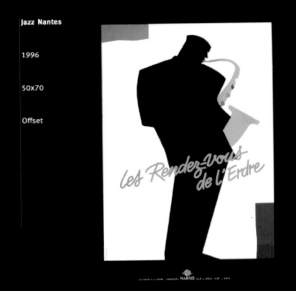

This four-color poster has a white background with a black silhouette of a man playing a yellow saxophone. João Machado specially designed the font for the 1996 event, Les Rendez-vous de l'Erdre.

CLIENT **Nantes Mairie (Nantes Municipal Council)**

João Machado designed this four-color poster in celebration of a hundred years of the Portuguese cinema. The background is blue with white and yellow type in Adagio Bold and Meta Plus Bold caps. The design features a black curly reel of film coming out of a projector. The red stripe at the top attracts attention.

CLIENT **Camara Municipal do Porto (O'Porto Municipal Council)**

100 Anos de
Cinema Português

1997

50x70

Offset

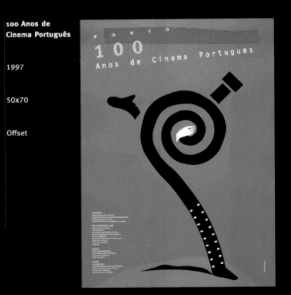

Designing stamps can be an interesting and rewarding task. João Machado designed these four-color stamps for the Portuguese Post Office to commemorate historic events and an important person. Titles include Jogos Olimpicos, Euro, 25 de Abril, and Jose Saramago.

Jogos Olimpicos – This stamp was dedicated to the hundredth anniversary of the International Olympic Committee.

CLIENT **CTT Correios de Portugal
(Portuguese Post Office)**

The logo section of João Machado's web portfolio features a variety of logos ranging from one color to four colors.

CLIENT **Bull & Bear Restaurant**

All the catalogs in João Machado's portfolio were designed for exhibitions. The different layouts presented exemplify the firm's versatility in designing both classic and modern looks.

OH BOY, A DESIGN COMPANY

OH BOY'S OBJECTIVE WAS TO DESIGN A COMPREHENSIVE ONLINE PORTFOLIO THAT CLIENTS AND PROSPECTS COULD ACCESS VIA THE WEB. THE VIEWER SEES NOT ONLY A CLIENT LIST BUT ALSO MULTIPLE SHOTS OF THE PORTFOLIO PIECES WITH A DESCRIPTION OF THE PROJECT. INFORMATION IS PRESENTED IN A CHART-LIKE LAYOUT FOR CLARITY AND READABILITY. A DETAILED CHART SHOWING TECHNICAL SPECIFICATIONS IS AVAILABLE DESCRIBING DESIGN CRITERIA (THE AUDIENCE), PRINT PROCESS AND SPECIFICATIONS, INKS, SUPPLEMENTAL SERVICES (COPYWRITING, ILLUSTRATION, PHOTOGRAPHY, PROGRAMMING), AND AWARDS. ICONS WERE DEVELOPED TO REPRESENT EACH CRITERION. BLACK AND WHITE, A NEUTRAL PALETTE, ALLOWS THE COLOR PORTFOLIO IMAGES TO STAND OUT ON SCREEN. THE PRIMARY FONT IS GENEVA, A SYSTEM FONT DESIGNED FOR SCREEN VIEWING, WHICH PIXELATES WELL AT ANY SIZE. TAHOMA WAS CHOSEN AS A SECONDARY FONT FOR PC USERS.

Oh Boy's opening page is simple, dark, and mysterious. The Japanese lettering says "Oh Boy" and "pulp" and "guide," all direct translations. The firm decided to use the Japanese lettering because of their affection for Kanji characters. The Pulp section is an online pulp serial. There will be updates to the storyline every three months or so.

WEB SITE DESIGNERS **David Salanitro, Alice Chang**

Consistent with the opening page, the client list page is predominantly black. The client name becomes highlighted in white by placing the mouse over it. A list of the various types of design work for a particular client appears to the right.

 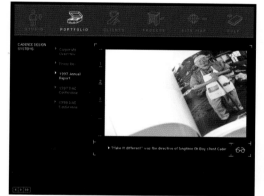 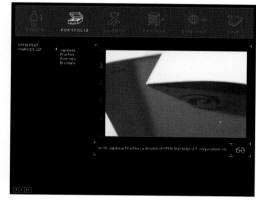

Once a design piece is selected, scrolling type describing the piece appears below. Cadence Design Systems' 1997 Annual Report was designed to be different. Thought-provoking questions, interesting photographs, and a clean design make this piece unique.

CLIENT **Cadence Design Systems**
DESIGNERS **Ted Bluey, David Salanitro**
PHOTOGRAPHERS **Ty Allison, Russell Monk**

Using predominantly red with hints of black, this book for Japanese Practice, a division of KPMG that facilitates commerce between U.S. and Japanese businesses, has Asian influence and appeal. It focuses on the unique differences in the ways each culture conducts business while at the same time encouraging international commerce.

CLIENT **KPMG Peat Marwick LLP**
DESIGNERS **David Salanitro, Mike Kraine**
PHOTOGRAPHERS **Francois Robert,
David Magnusson,
FPG (stock images)**

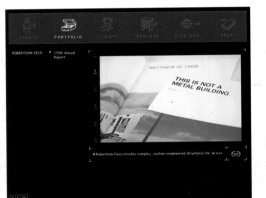

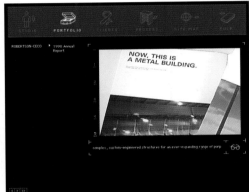

Robertson-Creo creates complex, custom-engineered structures such as public schools and sports arenas. The annual report was designed to dispel outdated notions of corrugated siding and tin roofs. The use of ample white space and a clean design with humorously direct copy does the job.

CLIENT **Robertson-Creo**

INTEGRATED
SYSTEMS, INC.

▶ pRISM+ and
Networking
Advertising

▶ 1998 Annual
Report

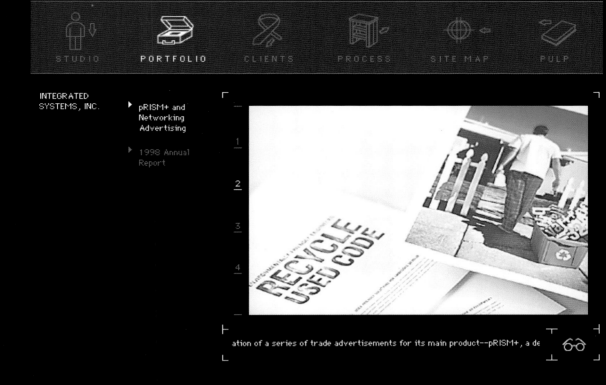

ation of a series of trade advertisements for its main product--pRISM+, a de

Integrated Systems, Inc. wanted a series of trade
advertisements for its main product, pRISM+. The ads
stayed away from overused technical product imagery
typical in computer trade publications. Instead, color
images such as a person with a recycle bin and a
computer code growing out of a flowerbed are used
to create a friendly, accessible tone.

CLIENT **Integrated Systems, Inc.**
DESIGNERS **David Salanitro, Mimi O Chun**
PHOTOGRAPHER **Ty Allison**

INTEGRATED
SYSTEMS, INC.

▶ pRISM+ and
Networking
Advertising

▶ 1998 Annual
Report

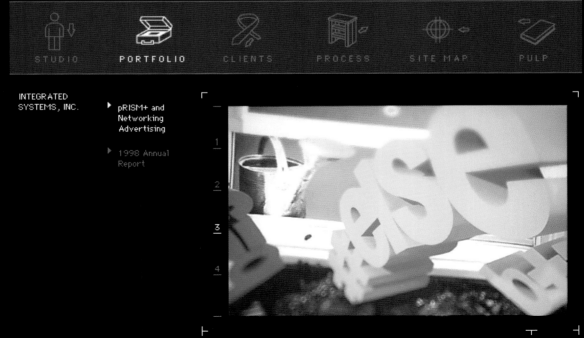

and a related series for its network development legacy code. Staying away

SMITH & HAWKEN ▸ Sweet's
Advertising

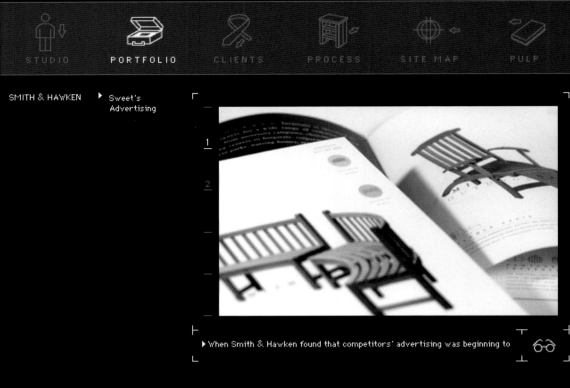

1

2

▸ When Smith & Hawken found that competitors' advertising was beginning to �6ᴓ

Intricate, iconic illustrations o
coupled with clean representat
the high quality, value, and sty
& Hawken's furniture. The effe
space and cool green highlight
pages contrast descriptive cop
reverse type.

CLIENT **Smith & Hawken**
DESIGNER **David Salanitro**

SMITH & HAWKEN ▸ Sweet's
Advertising

1

2

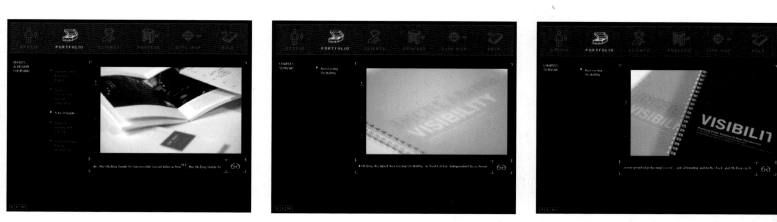

The Oh Boy 5-to-9 Guide 100-page, round-corner, spiral-bound appointment books were produced for clients and in house use. The white background, black type, and orange-red highlights tie in nicely with the firm's corporate identity.

CLIENT **Oh Boy, A Design Company**
DESIGNERS **David Salanitro, Ted Bluey**
PHOTOGRAPHERS **Ted Bluey, Mimi O Chun,
Oh Boy, A Design Company**

This spiral-bound, "Increasing Visibility" tool kit for independent investment managers uses a screen printed, opaque, polyvinyl cover and stock, and custom photography. Bold questions and answers and headlines depicting opportunities for increased exposure enhance the piece.

CLIENT **Charles Schwab**
DESIGNERS **Ted Bluey, David Salanitro**

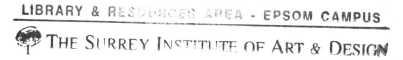

IMAGE: THE GENERAL IMPRESSION OF A PERSON OR FIRM OR PRODUCT, ET CETERA, AS PERCEIVED BY THE PUBLIC.

WHO ARE YOU? IT SOUNDS LIKE A SIMPLE QUESTION. BUT IF YOU DON'T KNOW THE ANSWER, NOBODY ELSE WILL EITHER. WHAT CONVEYS YOUR IMAGE? IT'S MADE UP OF YOUR CONVICTIONS. IT'S ABOUT WHAT INTERESTS YOU. IT'S ALL IN YOUR INTENTION. AS A DESIGNER, IT'S ABOUT THE WORK YOU DO. IT HAS TO DO WITH THE TYPES OF CLIENTS YOU REPRESENT. AND, MOST IMPORTANT, IT'S HOW YOU PRESENT YOURSELF.

IT'S INTERESTING THAT THE VERY WORD IMAGE HAS SUCH CONFLICTING MEANINGS. ON THE ONE HAND, IT IS AN IMPRESSION HELD BY THE PUBLIC ABOUT A FIRM OR INDIVIDUAL. ON THE OTHER HAND, IT IS AN INDIVIDUAL OR THING VERY MUCH LIKE ANOTHER– A COPY, A COUNTERPART, A LIKENESS.

A DIGITAL PORTFOLIO IS A REFLECTION OF YOU AS A DESIGNER. LIKE A TRADITIONAL PORTFOLIO, IT PROVIDES THE OPPORTUNITY TO SCINTILLATE, TO WOW YOUR AUDIENCE WITH YOUR OWN UNIQUE STYLE. BUT IT IS ALSO A WAY TO SHOW THAT YOU HAVE THE TECHNICAL SOPHISTICATION TO DIGITIZE WORK. YOU ARE ABLE TO BRIDGE THE GAP BETWEEN DIFFERENT MEDIUMS IN ORDER TO DISPLAY YOUR WORK IN A WHOLE NEW ENVIRONMENT. IT SHOWS THAT YOUR PRESENTATION SKILLS ARE INDICATIVE OF YOUR DESIGN SKILLS.

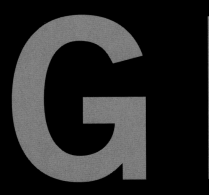

ASK YOURSELF, WHAT DO YOU WANT TO COMMUNICATE AND TO WHOM? WITH THE INFLUX OF COMPUTER TECHNOLOGY, IT BECOMES MORE CHALLENGING TO REACH YOUR INTENDED AUDIENCE. THE WEB AND CD-ROMS ALLOW YOU TO PUT YOUR WORK OUT THERE BEFORE MILLIONS, BUT WILL IT REACH WHO YOU WANT IT TO REACH? THE ATMOSPHERE CREATED BY SUCH TECHNOLOGY PROMOTES SELECTIVITY. WITH A CLICK OF A MOUSE, POTENTIAL CLIENTS HAVE THE ABILITY TO SKIP OVER WHAT YOU WANT THEM TO SEE. ZEROING IN ON YOUR STRENGTHS AS A DESIGNER AND FEATURING THEM IN THE FOREFRONT OF YOUR DIGITAL PORTFOLIO WILL HELP GET YOUR MESSAGE ACROSS. THEN LET YOUR INDIVIDUAL DESIGN PIECES DO THE REST.

IF YOU ARE SEEKING A PARTICULAR TYPE OF CLIENT, LET YOUR PORTFOLIO REFLECT IT. THE MARKET IS WIDE OPEN FOR MANY DIFFERENT APPROACHES. STRICTLY BUSINESS-LIKE APPEALS TO THE CORPORATE CLIENT. WHIMSICAL AND FUN ENGAGES ALMOST EVERYONE. CLEAN AND CLASSIC IS ALWAYS IN STYLE. PUSHING IT TO THE EDGE ATTRACTS THE TRENDY, HIP, EXTREME.

Maybe you don't want to be pigeonholed. After all, isn't it inbred in your nature as a designer to be an individual? What if by chance showing a variety of themes and various types of design work attracts that unlikely client? Categorizing your work by piece or industry can also showcase the full extent of your capabilities to diverse types of potential clients.

Whatever your focus or intent is, it's important to remember that your digital portfolio is an extension of you and your design style. Presenting your work in a way that doesn't mesh with your true style is deceptive. Clients will see right through. Hold true to your convictions. It's all about knowing who you are.

MINELLI DESIGN

AS A MULTIDISCIPLINARY STRATEGIC DESIGN FIRM, MINELLI DESIGN WORKS CLOSELY WITH CLIENTS WHO WANT TO ESTABLISH OR REDESIGN THEIR IDENTITY. THE FIRM PRODUCES AN ENTIRE CAMPAIGN—FROM PRINTED BROCHURES TO WEB SITES, DEPENDING ON WHICH APPLICATIONS MAKE SENSE FOR A PARTICULAR CLIENT. MINELLI DESIGN USES ITS DIGITAL PORTFOLIO TO MAKE LARGE GROUP PRESENTATIONS IN-HOUSE, IN ADDITION TO SENDING IT ON A CD-ROM TO POTENTIAL CLIENTS. WHEN DESIGNING ITS DIGITAL PORTFOLIO, THE FIRM WANTED TO MAKE SURE IT DISSEMINATED ITS OWN BRAND CORRECTLY, MAINTAINING COLOR, TYPOGRAPHY, AND MESSAGE IN A SIMILAR FORMAT TO OTHER PROMOTIONAL MATERIALS. FEATURED IN THE PORTFOLIO ARE EXAMPLES OF COMPLETE CAMPAIGNS, INCLUDING PRINT, DIGITAL MEDIA, ENVIRONMENTAL STRUCTURE, AND EXHIBITION WORK, AS WELL AS A CROSS SECTION OF WORK REPRESENTING A VARIETY OF MEDIA.

When Minelli Design redesigned its identity, it chose a color-branded green set against a black background for the digital portfolio. The green is vibrant, drawing attention, while the portfolio design is simple and clean, making it memorable. Minelli incorporated music in the background to help make the portfolio more emotional than static.

ART DIRECTION **Mark Minnelli**
DESIGN **Pete Minnelli, Brad Rhodes, Lesley Kunikas**
PROGRAMMING **John Cohoon, Sharon Boland**

Providing a client list in the portfolio allows potential clients to view work in their particular field in order to evaluate the latest trends as well as the competition. Minelli's clients span across the financial, educational, high technology, and health care sectors.

The Art Institute of Boston campaign contrasts the order and structure of the curriculum with darker, more emotive images that make reference to the creative spirit. Minelli used a flexible image that was contemporary typographically, mixing bold forms with introspective imagery.

CLIENT **Art Institute of Boston**
ART DIRECTION **Pete Minnelli**
DESIGN **Mark Minelli, Brad Rhodes,
 Lesley Kunikas, Michael Gerwe**

For the Art Institute of Boston campaign, Minelli provided a more uniform print system and created extensive digital applications to capitalize on emerging technologies. Viewers with Netscape 4.0 or higher are able to open brochures like this one to find out what's inside.

CLIENT **Art Institute of Boston**
ART DIRECTION **Pete Minnelli**
DESIGN **Mark Minelli, Brad Rhodes,
 Lesley Kunikas, Michael Gerwe**

For Fidelity Investments' national corporate client conference in 1995, Minelli Design developed cohesive verbal and visual positioning that brought all aspects of the conference together under one umbrella, incorporating print, presentation matter, and major exhibit space.

CLIENT **Fidelity Investments**
ART DIRECTION **Mark Minelli, Pete Minnelli**
DESIGN **Brad Rhodes, Lesley Kunikas**

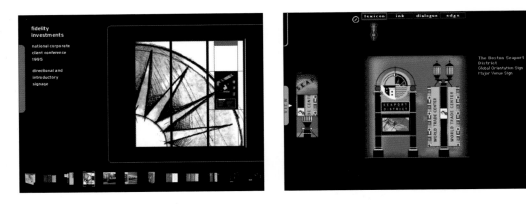

In 1996, Minelli Design proposed the concept, framework, and goals for The Boston Seaport District Identity and Signage project. The project's central mission is to create an engine and framework for the development of an evolving, sustainable neighborhood that will invite pedestrians, guiding them along the waterfront area and to public venues and transportation. Minelli developed this Global Orientation Sign and Major Venue Sign, along with various other signage and kiosks for The Boston Seaport District.

CLIENT **The Boston Seaport District**
ART DIRECTION **Mark Minelli**
DESIGN **Brad Rhodes, Michael Gerwe**

IMAGE

lexicon ink dialogue edge

VIEW

Lotus Development Corporation
Domino Technical Workshop Mailer

The Domino Technical Workshop mailer was conceived for a series of Lotus Development Corporation workshops held across the country geared toward the developer community. Minelli Design wanted to package the seminars in an active, engaging fashion that promoted the Lotus brand. The design is technically precise and very legible.

CLIENT **Lotus Development Corporation**
ART DIRECTION **Mark Minelli**
DESIGN **Lesley Kunikas**

BIG BLUE DOT

PROVIDING KID-ORIENTED GRAPHIC DESIGN WORK FOR THOSE IN THE KIDS BUSINESS IS BIG BLUE DOT'S MISSION. THE BIG BLUE DOT WEB PORTFOLIO WAS DESIGNED TO HIGHLIGHT ITS WORK IN AN ENVIRONMENT THAT REFLECTED ITS FLAVORFUL AND ECLECTIC STYLE. THE PORTFOLIO REFLECTS A KID-LIKE STYLE WITH BOLD COLORS AND WACKY ICONS. THE COLORS COME FROM THE WARM SIDE OF THE PALETTE. THEY ARE SUNNY AND BRIGHT AND GIVE A GOOD HOME TO THE BIG BLUE DOT LOGO. THE PORTFOLIO HAS A FEELING OF TEXTURE AND PHYSICALITY DUE TO THE PATTERNS AND REAL 3-D OBJECTS. BIG BLUE DOT ADDED LAYERS OF TYPE AND PHOTOGRAPHIC OBJECTS TO FURTHER ACHIEVE THE DESIRED EFFECT. TO KEEP THE DESIGN WORK FRONT AND CENTER, THE FIRM KEPT NAVIGATIONAL GRAPHICS TO A MINIMUM. VISUAL PUNS LIKE THE LOGO ICON AND THE NEWS HOUND REFLECT ITS PLAYFUL AND UNPREDICTABLE STYLE.

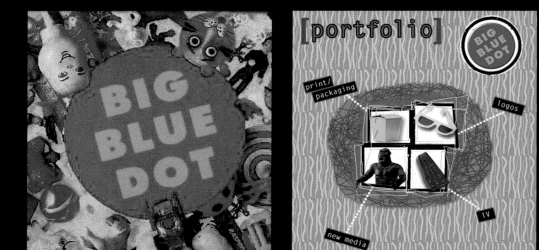

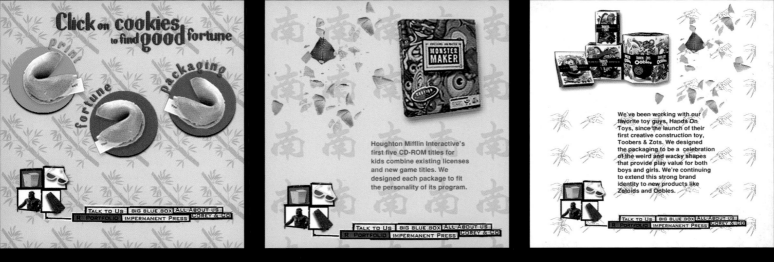

The print/packaging section uses the theme of fortune cookies for the subsections. When the viewer clicks on the fortune cookie, a seemingly endless fortune appears.

Houghton Mifflin Interactive's first five CD-ROM titles for kids combine existing licenses and new game titles. BIG BLUE DOT designed each package to fit the personality of its program.

Awesome Animated Monster Maker is published by Houghton Mifflin Interactive. Awesome Animated Monster Maker is a trademark of ImaginEngine Corp.

BIG BLUE DOT has been working with Hands On Toys since the launch of the company's first creative construction toy, Toobers and Zots. The packaging is designed to celebrate the weird and wacky shapes that provide play value for both boys and girls. BIG BLUE DOT is continuing to extend this strong brand identity to new products like Zotoids and Oobles.

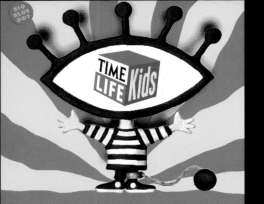

LOGOS

A corporate or brand identity for kids should be recognizable - at the blink of an eye! At the same time, we find that kids respond to logos that evoke a sense of humor and imagination. Take a look at some of the eye popping logos

LOGOS

A corporate or brand identity for kids should be recognizable - at the blink of an eye! At the same time, we find that kids respond to logos that evoke a sense of humor and imagination.

LOGOS

A corporate or brand identity for kids should be recognizable - at the blink of an eye! At the same time, we find that kids respond to logos that evoke a sense of humor and imagination.

Getting the attention of kids and keeping it is paramount in designing logos for the kid market. Since many clients rely on brand identity, a recognizable logo is key.

CLIENT **Time Life Kids**
ART DIRECTOR **Scott Nash**
DESIGNER **Tim Nihoff**

CLIENT **Nickelodeon**
ART DIRECTOR **Original Concept:**
Tom Corey, Scott Nash

CLIENT **Hanna-Barbera**
DESIGNER **Tom Corey**

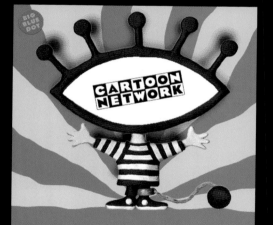

LOGOS

A corporate or brand identity for kids should

be recognizable - at the blink of an eye!

At the same time, we find that kids respond to logos

that evoke a sense of humor and imagination.

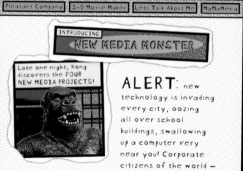

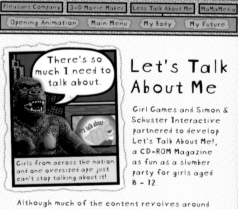

CLIENT **Cartoon Network**
ART DIRECTOR **Tom Corey**
DESIGNER **Tom Corey**

Cartoon Network Logo is used with the permission of
and is a trademark of Cartoon Network LP, LLLP.

As technology advances, new media designed
specifically for kids becomes increasingly important.
The New Media page uses Kong, a friendly creature,
to market BIG BLUE DOT's new media products. Kong
appears throughout the site, spurting out what is
on his mind.

"Let's Talk About Me" is a CD-ROM magazine
developed with Simon & Schuster Interactive. Geared
toward girls aged 8 to 12, the content includes topics
of interest to girls, as well as information on careers
and self-esteem.

CLIENT **Simon & Schuster Interactive**
ART DIRECTOR **Susan Gilzow**
DESIGNER **Susan Gilzow**

JOEL NAKAMURA

WHEN ILLUSTRATOR JOEL NAKAMURA PUT TOGETHER HIS ELECTRONIC PORTFOLIO, THE DESIGN WAS A REFLECTION OF HIS PERSONALITY AND WORK. HIS METHODS AND PROCESS INVOLVE A SYNTHESIS OF SENSIBILITIES INSPIRED FROM FOLK ART, PRIMITIVES, AND AN AFFINITY WITH MODERN PAINTING. THE RESULT IS A TYPE OF MODERN FOLK PAINTING REPORTING SOCIAL AND POLITICAL THEMES, OR TALKING ABOUT CONTEMPORARY COLLOQUIALISMS. USING MYTHOLOGICAL SYMBOLISM FOR HIS INSPIRATION, NAKAMURA WANTED HIS PORTFOLIO TO BE FANCIFUL AND FUN. THE DESIGN IS CLEAN AND WITHOUT FRILLS. A SENSE OF THE SOUTHWEST PERMEATES THROUGHOUT HIS WEB PORTFOLIO WITH A BRIGHT, ETHNIC COLOR SCHEME.

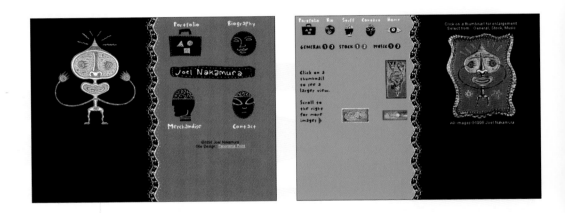

Nakamura combines iconography and narrative symbolism in his design work. His work has been described as folk art with a bizarre urban edge.

Nakamura's web portfolio has three main subsections: General, featuring commissioned work; Stock, containing illustrations for sale; and Music, exhibiting numerous music CD and album covers. All three function separately, and each appeals to a slightly different type of potential client.

"Have a Heart. Give a Hand" was the theme for a
United Way/Bank of America fundraising campaign.
Nakamura's use of narrative symbolism makes this
poster image both entertaining and thought-provoking.

CLIENT **United Way/Bank of America**
ART DIRECTOR **Larry Bruderer**

Entitled "The Mating Game," this illustration
complemented an article in *U.S. News & World
Report* about primordial reproductive instincts.

CLIENT **U.S. News & World Report**
ART DIRECTOR **Michelle Chu**

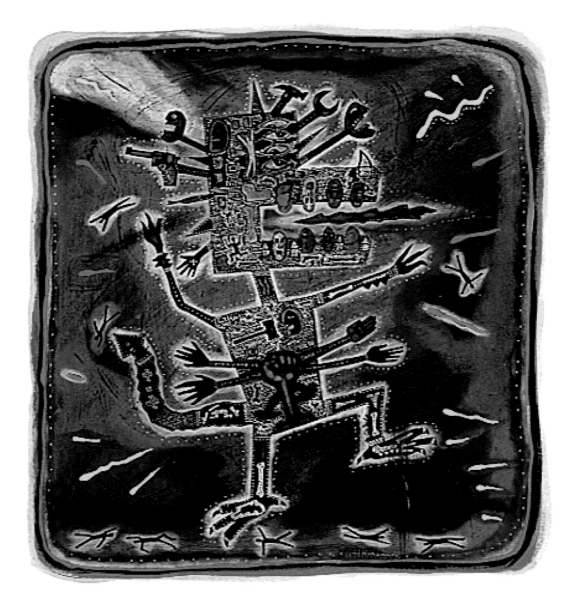

When the Los Angeles Times Magazine did an article on the Los Angeles riots, Nakamura was asked to provide an illustration. His piece conveys the collective anger and frustration that is involved in creating a monster.

CLIENT **Los Angeles Times Magazine**
ART DIRECTOR **Nancy Duckworth**

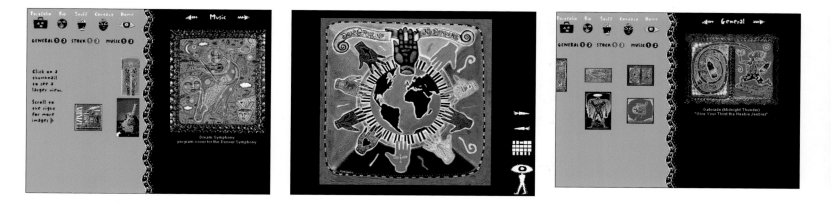

Nakamura combines iconography and narrative
symbolism in much of his design work. In this piece
for the Denver Symphony, he uses cool, night colors
and sleeping images to symbolize the Dream Symphony.

CLIENT **The Denver Symphony**

A 1993 Communication Arts winner, this illustration
for Don Grusin's album "No Borders" for GRP Records
portrays that music is universal and knows no borders.

CLIENT **GRP Records**
ART DIRECTOR **Andy Baltimore**

This poster was created for Gatorade's Midnight
Thunder campaign entitled "Give Your Thirst the Hee-
bie Jeebies."

CLIENT **Gatorade**

GRANT JERDING

DESIGNING INFORMATION GRAPHICS CAN BE DIFFICULT, ESPECIALLY SINCE MUCH OF THE DESIGN WORK MUST CENTER AROUND THE TEXT. THEREFORE, GRANT JERDING MINIMIZES THE USE OF TYPE, OFTEN USING ONLY ONE FONT IN SMALL LOWERCASE LETTERS. AS A GRAPHIC ARTIST FOR *USA TODAY*, MUCH OF JERDING'S WORK ENTAILS DESIGNING GRAPHICS OF HIGH TECHNOLOGY. JERDING BRAINSTORMS FOR IDEAS ON HOW TO PORTRAY DIFFICULT INFORMATION TO THE AVERAGE READER. ONE OF THE CHALLENGES IS CHOOSING OBJECTS THAT READERS CAN IDENTIFY WITH OR EASILY RECOGNIZE. JERDING'S PORTFOLIO CONSISTS OF HIS INFORMATION GRAPHICS AS WELL AS SOME OF HIS OWN CREATIVE DESIGNS. BY SHOWING VERSATILITY IN A PORTFOLIO, POTENTIAL CLIENTS ARE AWARE OF HIS STRENGTHS IN INFORMATION GRAPHICS AS WELL AS HIS FULL CAPABILITIES FOR OTHER DESIGN WORK. THE MEDIUM, PHOTO ILLUSTRATION; THE USE OF TEXTURE, LAYERING, AND TRANSPARENCY; AND THE CONCEPTUAL APPROACH ARE CONSISTENT THROUGHOUT.

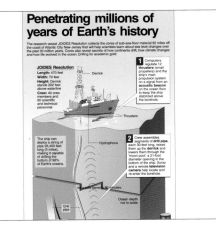

The weather buoy explanatory piece was created for *USA Today*'s weather page in 1998. The piece describes the role buoys play in helping meteorologists forecast the weather and predict hurricanes. The ocean was created in PhotoShop, while the rest of the piece was drawn in FreeHand.

CLIENT **USA Today**
RESEARCHER **Christopher J. Vaccaro**
SOURCE **National Data Buoy Center**

This ocean-drilling how-to graphic was created for *USA Today* in 1997. It explores how the research vessel Joides Resolution collects cores of sub-seafloor material.

CLIENT **USA Today**

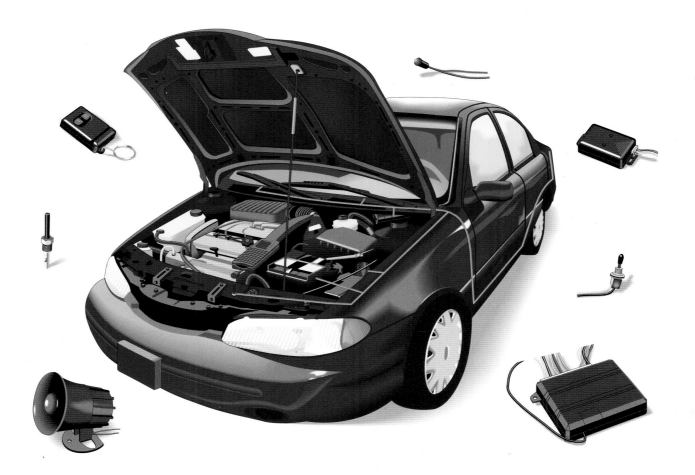

Jerding used FreeHand to create an auto-alarm
illustration for *Consumer Reports* that included a total
of 108 blends. Close-ups of the auto-alarm components
are scattered around the car. Information graphics
require adequate space for detailed text descriptions.

CLIENT **Consumer Reports**

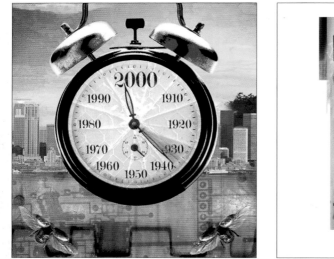

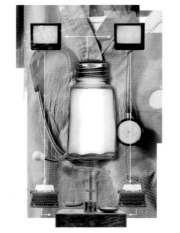

The Y2K dilemma is a timely topic, literally. Jerding used a clock to show that time is ticking for a *USA Today* article in 1998.

CLIENT **USA Today**

Created for *Emerge* magazine in 1998, this photo illustration portrays the media's hype and interpretation of medical studies. Since the writer used studies on salt and hypertension as an example throughout the article, Jerding used the salt shaker and a stethoscope to highlight this piece.

CLIENT **Emerge**

This photo illustration was created for *Family Money* magazine in 1999 for an article on stock splits. The art director requested a visually stimulating piece that illustrated the actual process of the stock splitting. The final version appeared without the gymnast doing the splits along with a different background.

CLIENT **Family Money**

Originally created for *Bloomberg* magazine, this digital
photo collage illustrated an article on how to purchase
the perfect custom suit. This concept has been reprised
with some modifications for pieces in *Scientific Ameri-
can* on genetic engineering and for Impulse,
a German magazine about starting a company.

CLIENT **Bloomberg**

INTERNET BROADCASTING SYSTEMS

INTERNET BROADCASTING SYSTEMS SPECIALIZES IN DEVELOPING AND MAINTAINING HIGHLY INTERACTIVE AND INFORMATIVE NEWS-BASED WEB SITES FOR TELEVISION STATIONS. IBS FORMS A PARTNERSHIP WITH THE STATION AND DESIGNS AND MAINTAINS THE SITE IN EXCHANGE FOR ON-AIR PROMOTION. WHEN ESTABLISHING A WEB PORTFOLIO, IBS DECIDED TO MIRROR THE CHANNEL CONCEPT OF ITS CLIENTS. THE DESIGN ALSO HAD TO BE CONSERVATIVE ENOUGH TO BE AN EFFECTIVE COMMUNICATION TOOL. IBS CHOSE WEB-SAFE COLORS THAT WERE HIGH IN CHROMA TO COMMUNICATE THE HIGH-ENERGY ATMOSPHERE OF THE COMPANY. THE FONT MATCHES THE COMPANY'S CURRENT PRINT COLLATERAL. THE GRAPHIC STYLE IS AN ABSTRACTION OF FLOW CHARTS AND TECHNICAL DRAWINGS MEANT TO COMMUNICATE THE TECHNICAL ASPECT OF THE BUSINESS.

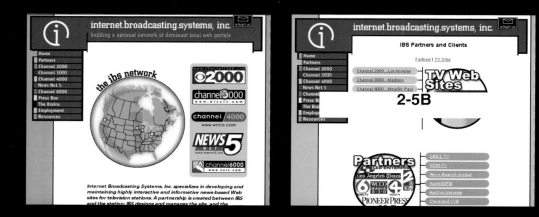

Visually appealing, this portfolio home page features a map pinpointing the location of all Internet Broadcasting Systems television station partnerships across the United States. Channel logos are displayed to the right, where viewers can click on them to go to a particular channel.

Partner television stations are located in Los Angeles, Madison, Minneapolis, Cleveland, and Portland. While television stations are IBS's main clients, other partners include news organizations such as newspapers, magazines, and radio stations.

CLIENT: **Internet Broadcasting Systems, Inc.**

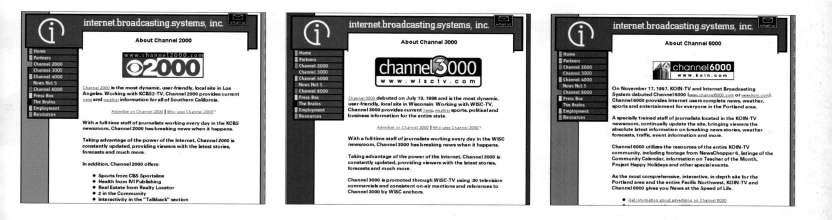

Channel 2000 is Southern California's news web site
working with CBS2-TV.

CLIENT **Internet Broadcasting Systems, Inc.
and KCBS TV Los Angeles**
DESIGNER **Brent Asproth**

Channel 3000 covers the entire state of Wisconsin.
Based out of Madison, Wisconsin, the channel works
in conjunction with WISC-TV.

CLIENT **Internet Broadcasting Systems, Inc.
and KCBS TV Los Angeles**
DESIGNER **John Barton**

Channel 6000 and KOIN-TV service the Portland area
as well as the entire Pacific Northwest.

CLIENT **Internet Broadcasting Systems, Inc.
and KOIN-TV Portland, Oregon**
DESIGNER **Amy Johnson**

CHARLIE HILL

CHARLIE HILL USES A LOT OF NEGATIVE SPACE WITHIN THE PORTFOLIO DESIGN SO AS NOT TO DETRACT FROM THE IMAGERY. HE USES A BLACK BACKGROUND NOT ONLY TO MAKE THE IMAGES APPEAR TO GLOW MORE BUT ALSO BECAUSE IT RELATES TO THE TRADITIONAL TRANSPARENCY PORTFOLIO. HILL USES SPARE VERBIAGE AND STAYS AWAY FROM TOO MUCH DESCRIPTIVE INFORMATION IN ORDER TO KEEP THE DESIGN AT THE FOREFRONT. THIS ALSO HELPS THE PROSPECTIVE CLIENT KEEP AN OPEN MIND FOR THE POTENTIAL USE OF THE IMAGERY. THE PORTFOLIO DESIGN IS AS SIMPLE AND UNOBTRUSIVE AS POSSIBLE. THE WORK IS REALLY THE ONLY THING THAT HILL WANTS VIEWERS TO NOTICE. HE DOESN'T WANT THE DESIGN OF THE PORTFOLIO TO CALL ATTENTION TO ITSELF.

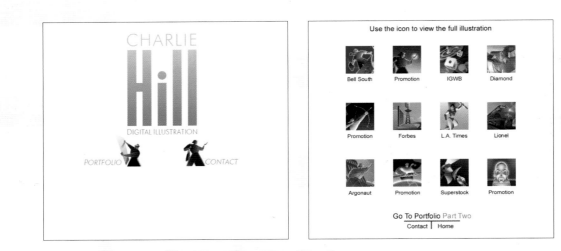

Hill tries to work with imagery that won't become dated, that which was appropriate twenty years ago or would be appropriate twenty years from now.

Hill keeps the colors rich and saturated, but always at the service of the basic design of the illustration.

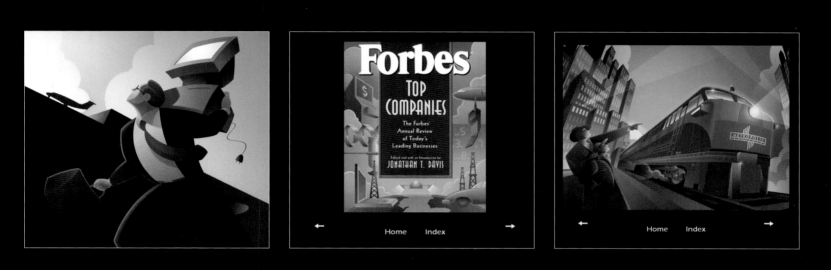

Xircom wanted to depict the need for an efficient method of "taking your office on the road."

CLIENT **Xircom**

Forbes was interested in using only objects to portray the corporations. The artwork had to conform to a standard type layout that Forbes uses annually for these books.

CLIENT **Forbes**

From people to packages, the train has been an invaluable source for transportation all over the world. Hill portrays the power, mystery, and glamour of trains in the box art for a Lionel toy train.

CLIENT **Lionel Trains**

← Home Index →

← Home Index →

This panorama was used for the wrap around Argonaut's annual report.

CLIENT **Argonaut**

Laptop computers have taken the business world by storm. This design was created to show the prevalence of laptops in the corporate world.

CLIENT **Xircom**

We've come a long way since kites and lightning were used to generate electricity. Superstock wanted to use traditional imagery to illustrate the power of modern technology.

CLIENT **Superstock**

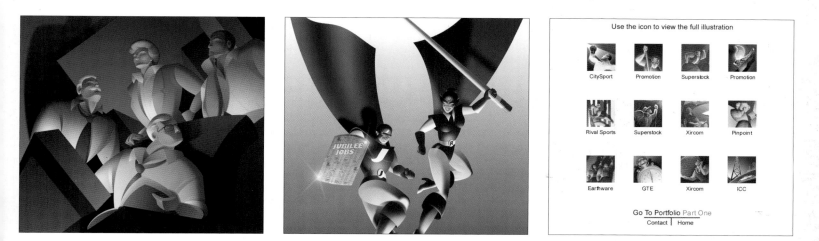

Norton's intent was to show camaraderie in the office space with computers.

CLIENT **Norton's**

The *Los Angeles Times* asked Hill to update existing characters for this series of illustrations promoting the *LA Times* classified section.

CLIENT ***Los Angeles Times***

Hill wants the viewer to notice his design work, not his portfolio design. As a result, the portfolio is simple and unobtrusive.

FIND A NATURAL ORDER.

DESIGNING A SUCCESSFUL DIGITAL PORTFOLIO CAN BE SOMEWHAT OF A CONUNDRUM. ON THE ONE HAND, YOU WANT TO SHOW THE BROADEST RANGE OF WORK, SPANNING A PLETHORA OF DESIGN CATEGORIES, SUBJECT MATTERS, STYLES, AND TECHNIQUES. AT THE SAME TIME, IT'S IMPORTANT TO PRESENT A UNIFIED LOOK. MIXING MEDIA CAN BRING SEVERAL QUESTIONS TO MIND. HOW MUCH TO INCLUDE? HOW TO ORGANIZE IT? AND HOW DO YOU DISPLAY DIFFERENT DESIGN CATEGORIES? DO YOU PRESENT BY TYPE OF CLIENT? DESIGN PIECE? CAMPAIGN? ASSUMING A POTENTIAL CLIENT HAS ONLY TEN TO FIFTEEN MINUTES TO REVIEW YOUR WORK, YOU'D BETTER CHOOSE WISELY.

PLACEMENT OF WORK PLAYS A ROLE WITH ANY TYPE OF PORTFOLIO, DIGITAL INCLUDED. HERE'S WHERE IT'S IMPORTANT TO FOLLOW A COHESIVE DESIGN STRATEGY. FIND A NATURAL ORDER, A LOGICAL SEQUENCE. TRADITIONALLY, YOU WANT TO PUT YOUR STRONGEST IMAGES IN FRONT TO GRAB A PROSPECTIVE CLIENT'S ATTENTION, THEN END WITH A STRONG PIECE THAT WILL LINGER IN HIS MIND—LIKEWISE WITH A DIGITAL PORTFOLIO. OTHER TRADITIONAL PORTFOLIO DESIGN STRATEGIES APPLY AS WELL, SUCH AS GOING FROM SIMPLE TO COMPLEX IMAGES, CLOSE-UPS TO LONG VIEWS, DETAILS TO FULL SHOTS, AND SO ON.

One major difference with a digital portfolio is that you have the opportunity to include much more work, given the limitless capabilities of an electronic format. Not only that, but large-scale environmental work and multimedia work that was not conducive for display in a traditional portfolio can now be presented in a digital format. With this in mind, auditing the digital portfolio is a must. Use personal instinct and place yourself in the viewer's mind. When do you stop paying attention? When do you zone-out? Many believe that if they aren't intrigued in the first five minutes, they won't be in the next ten minutes either. What does it take to win over a client? When does enough become too much? In regards to size, most say no more than twenty pieces should be included in a digital portfolio. Any more than three to four design pieces in a given subject area is more than most people can handle. The challenge is in getting the right mix to cover all the bases. It's also known that larger portfolio images discourage people from going very deep. Smaller thumbnails tend to work better because they allow viewers to poke around easily since download time is much quicker.

TWO EFFECTIVE STRATEGIES FOR PRESENTING WORK FOCUS ON EITHER DESIGN TYPE OR CLIENT. BOTH STRATEGIES HAVE SUCH NOTABLE ATTRIBUTES THAT SOME DESIGNERS FEATURE WORK IN BOTH WAYS, TO MAXIMIZE THE EFFECTIVENESS OF THEIR PRESENTATION. COMMON DESIGN TYPES INCLUDE CATEGORIES SUCH AS PRINT, PACKAGING, CORPORATE IDENTITY, LOGOS, ENVIRONMENTAL, MULTIMEDIA, AND WEB SITE DESIGN. FEATURING WORK BY CLIENT TAKES A SLIGHTLY DIFFERENT TWIST. IT IS ATTRACTIVE BECAUSE IT ALLOWS POTENTIAL CLIENTS TO SEE THE POSSIBILITIES AVAILABLE FOR A VARIETY OF DESIGN WORK. IT ALSO ALLOWS THEM TO CHECK OUT THE COMPETITION OR GET IDEAS FROM FIRMS THEY RESPECT. THE ADVANTAGE OF ORGANIZING BY DESIGN TYPE IS THAT VIEWERS ARE ABLE TO EXPLORE THE CATEGORIES THAT INTEREST THEM, AND THEY DON'T WASTE TIME ON THINGS THEY DON'T WANT TO SEE. POTENTIAL CLIENTS APPRECIATE EFFICIENCY; THEY WANT TO DIVE IN AND GET OUT QUICKLY.

MEDIA

Updating a digital portfolio is much easier than updating the traditional black book. In a perfect world, you would update your portfolio at least every quarter. In reality, most designers are lucky if they get to it every six months. It's the kind of thing to do whenever you have downtime—as if that ever happens. With millions of web surfers on the net every day, material gets dry very quickly. If a viewer doesn't see anything new, your web site sends out the message that nothing's going on. Since many potential clients will check back periodically (whenever it's time for a new piece), it's important to update and add new work as it is created.

Perhaps the most important reason to mix the media in your digital portfolio is because it's similar to life; people don't always know what they want until they see it. A prospective client, who was only interested in some letterhead, may decide on a complete identity redesign after surfing your web portfolio. The perfect motivation for auditing, updating, and revising until you find the perfect mix.

YAMAMOTO MOSS

YAMAMOTO MOSS' WEB PORTFOLIO REFLECTS THE COMPANY PERSONALITY IN AN ORIGINAL PAINTING ENTITLED *ENDLESS IMAGINATION* BY PRINCIPAL MIRANDA MOSS. THE PAINTING DEPICTS THE SYMBOLS OF EAST AND WEST, OF YAMAMOTO AND MOSS. SECTIONS OF THE PAINTING APPEAR THROUGHOUT THE WEB SITE, MAINTAINING A CONSISTENT IDENTITY. THE TREE IN THE PAINTING REPRESENTS THE PORTFOLIO SECTION OF THE SITE. THE APPLES ON THE TREE RIPEN AS THE VIEWER CHOOSES DIFFERENT LEVELS OF THE PORTFOLIO. COLORS FROM THE COOL SIDE OF THE PALETTE CREATE A RELAXING AND ENCHANTING ENVIRONMENT THAT MAKES ONE WANT TO ENTER THE SITE FOR A FANTASTICAL ADVENTURE.

YAMAMOTO MOSS HAS DEVELOPED A PARTNERSHIP WITH DIA LONDON AND DIA SINGAPORE IN ORDER TO PROVIDE A EUROPEAN PRESENCE FOR CLIENTS WITH INTERNATIONAL DESIGN NEEDS. SOME OF THIS WORK IS ALSO INCLUDED IN THE PORTFOLIO.

The apples represent the different types of design work in which Yamamoto Moss specializes. Placing the mouse over one of the apples causes it to "ripen," turning a bright red.

Signage is a language unto itself. It is also quite an art. It not only needs to be visually appealing but also easy to find and read.

Yamamoto Moss designed a vibrant plaza outside
Hubert H. Humphrey Metrodome, complete with
sculpture and signage. The firm also designed
directional signs, banners, and billboards.

CLIENT **Hubert H. Humphrey Metrodome**

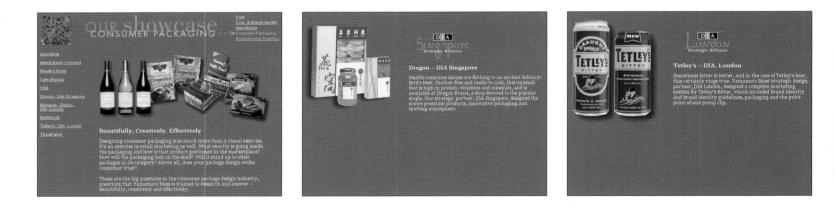

Designing consumer packaging is so much more than a visual exercise. It's an exercise in retail marketing as well.

Yamamoto Moss' strategic partner DIA Singapore designed Dragon Brand's premium products, innovative packaging, and inviting atmosphere. The store is devoted to Bird's Nest, a popular Asian staple.

CLIENT **Dragon Brand**
DESIGN FIRM **DIA Singapore**

Yamamoto Moss' strategic design partner DIA London designed a complete marketing system for Tetley's Bitter beer.

CLIENT **Tetley's**
DESIGN FIRM **DIA London**

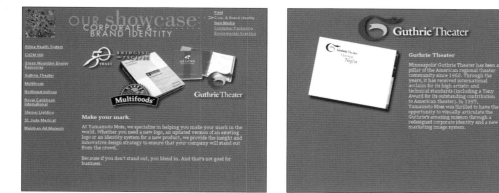

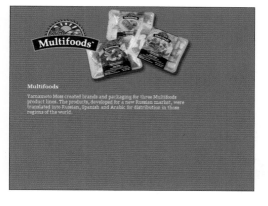

Various new logos, updated versions of existing logos, and complete identity systems are featured in the Corporate & Brand Identity section.

Yamamoto Moss redesigned the corporate identity and installed a new marketing image system for the Guthrie Theater, the premier regional theater in Minneapolis.

CLIENT **Guthrie Theater**

Three Multifoods product lines needed new brands and packaging. The products, developed for a new Russian market, were translated into Russian, Spanish, and Arabic for distribution in those regions of the world.

CLIENT **Multifoods**

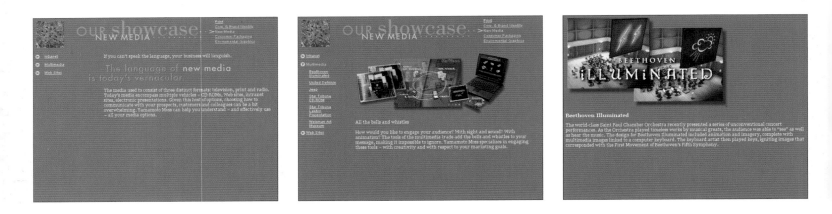

Today's media encompass multiple vehicles, including CD-ROMs, web sites, Intranet sites, and electronic presentations.

The tools of the multimedia trade add the bells and whistles to a message, making it impossible to ignore.

Beethoven Illuminated, presented by the Saint Paul Chamber Orchestra, included animation and imagery, complete with multimedia images linked to a computer keyboard.

CLIENT **Saint Paul Chamber Orchestra**

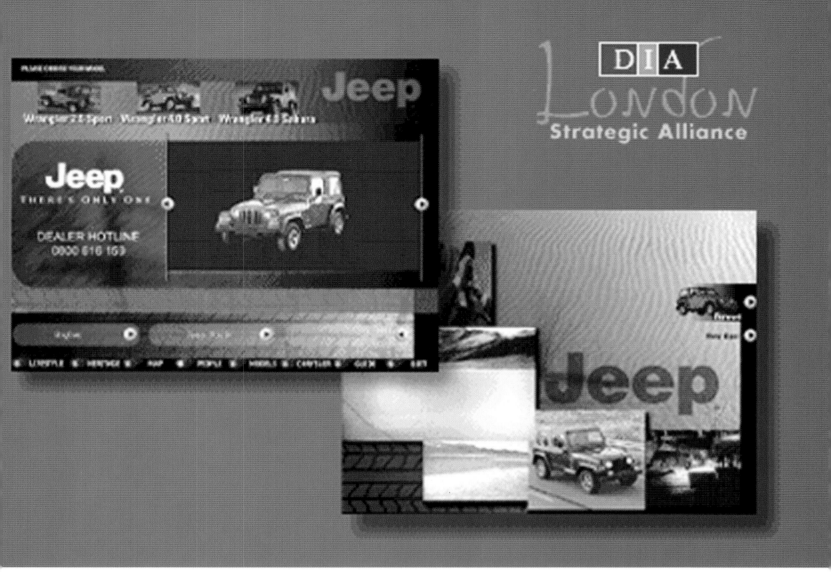

DIA London designed an entertaining and exciting
CD-ROM promoting the Jeep Wrangler. Viewers could
take a "virtual road trip" or paint the Jeep in a color
of choice.

CLIENT **Jeep**
DESIGN FIRM **DIA London**

WEB PRESENCE NETWORKING

WEB PRESENCE NETWORKING, LLC HAS TWO DIGITAL PORTFOLIOS—AN ONLINE PORTFOLIO AND A FLASH PORTFOLIO. THE DESIGN OF THE ONLINE PORTFOLIO DRAWS ON THE FAMILIAR LOOK OF A KIOSK INTERFACE WHILE MAINTAINING USABILITY ON THE WEB. FONTS AND COLORS MAINTAIN THE IDENTITY OF WEB PRESENCE NETWORKING, WHILE TEXTURES AND PATTERNS TAKE THE LOOK A STEP FURTHER. ICONS ARE USED TO DISTINGUISH THE VARIETY OF SERVICES OFFERED. WHEN COMBINED WITH ONE ANOTHER, THEY SHOW A QUICKLY COMPREHENSIBLE OVERALL LOOK AT THE EFFORTS INVOLVED IN THE PROJECTS.

THE FLASH PORTFOLIO WAS DESIGNED TO CONVEY A SENSE OF URGENCY AND COMPETITION IN THE FAST PACED WORLD OF TECHNOLOGY. IT TAKES GOOD IDEAS AND A RELENTLESS EFFORT TO STAY AHEAD IN THIS WORLD. PHOTOS OF ATHLETES IN COMPETITION HELP EMPHASIZE THIS MOTIF. THE SOUND IS VERY UPBEAT, AND "GRUNGY," WHICH ADDS TO THE NEW AGE COMPETITIVE APPROACH. ALSO, A CLEVER USE OF LINE MOVEMENT, ORANGES, BROWNS, AND SEPIA TONES GIVE THIS PIECE A UNIQUE CONSISTENCY.

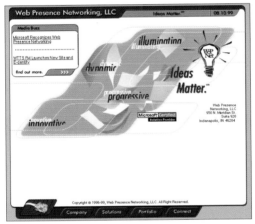

WEB PRESENCE NETWORKING, LLC HAS RECENTLY CHANGED ITS NAME TO EXPIDANT.

The Web Presence Networking, LCC online portfolio is an extension of the firm's identity. The animated light bulb and moving graphics hold the viewer's attention.

The online portfolio was meant to draw on the familiar look of a kiosk interface. Red navigation buttons on the bottom lead the viewer into the portfolio section.

DESIGNER **Doug Scamahorn, Creative Director**
COPY WRITING **Steven McLaughlin, Principal**

Our Clients

Web Presence Networking works with a wide variety of companies and organizations. Our clients range from non-profits to Fortune 500 companies who demand a competitive edge. Our online portfolio gives a brief snap-shot of our clientele and capabilities. To request a complete listing of our clients and solutions please contact us.

Portfolio

Strategy

Design

E-Commerce

Database

Multimedia

Media Planning

Flash Portfolio

Strategy

Dow AgroSciences

Dow Chemical

National Healthcare Technologies, Inc.

Design

Personnel Management, Inc.

Pleasant Run, Inc.

Education Services Corporation (ESC)

E-Commerce

Cellular Depot

Tau Kappa Epsilon

Kiwanis International

Database

Lambda Chi Alpha

CitiQuest

XFMRS, LLC

Multimedia

Media Planning

Company / Solutions / Portfolio / Connect

0

The portfolio index on the upper right lists design categories including Strategy, Design, E-Commerce, Database, Multimedia, Media Planning, and Flash Portfolio. Potential clients are able to view the portfolio in two versions, the Project Portfolio and the Enhanced Flash Portfolio.

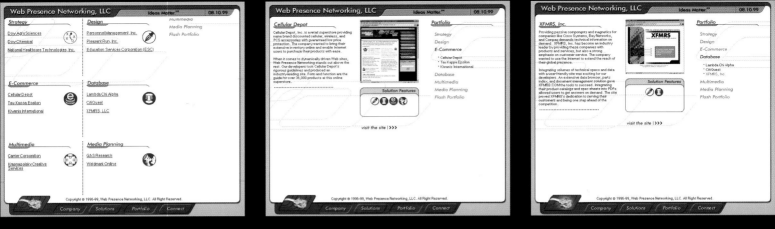

Education Services Corp., an organization that provides customized fundraising programs for schools and other not-for-profits wanted a dynamic Internet/Intranet/Extranet presence to serve their sales force and customers. Web Presence won a Citation of Excellence Award in the 28th Annual Advertising Awards competition for this project.

CLIENT **Education Services Corp.**

Web Presence's E-Commerce work includes a web site for Cellular Depot, Inc., a retail superstore that sells discounted cellular, wireless, and PCS accessories. The company wanted to bring its extensive inventory online to enable viewers to purchase products. The black-and-white background is enhanced by multicolored buttons from across the palette.

CLIENT **Cellular Depot, Inc.**

Helping create databases is another of Web Presence's offerings. XFMRS, Inc., which provides passive components and magnetics for companies like Cisco Systems and Compaq, wanted more of an Internet presence. Web Presence helped it integrate product catalogs and spec sheets into PDFs, which allowed users to get answers on demand. The vibrant green, black, and white are an extension of the identity.

CLIENT **XFMRS, Inc.**

Krasnapolsky

Krasnapolsky creative services combines over 10 years experience in design and advertising to provide ideas, speed and power on demand. Their range of capabilities span identity, TV, advertising, and illustration. As part of a new marketing initiative the firm decided to produce an interactive CD-ROM.

Web Presence Networking's multimedia developers crafted a unique interactive experience for users. Sound, motion, video, and style capture the essence of Krasnapolsky's own identity. CD-ROM users take away an entertained and informed mindset from the project.

People/Resources
Visit the Studio
of Sadia Krasnapolsky

portfolio

Krasnapolsky
creative services

Solution Features

Portfolio

Strategy

Design

E-Commerce

Database

Multimedia

- Carrier Corporation
- Krasnapolsky Creative Services

Media Planning

Flash Portfolio

78
79

MIXING MEDIA

Company Solutions Portfolio Connect

Krasnapolsky Creative Services wanted to produce an interactive CD-ROM as a part of a new marketing initiative. The design and advertising firm has produced work in television, advertising, identity, and illustration. Web Presence created the sound, motion, and style of this CD-ROM. A motorcycle rider cruises across the green screen. The company name and the word Portfolio print in the background.

CLIENT **Krasnapolsky Creative Services**

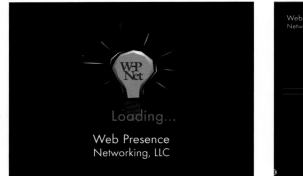

The goal with the Flash version of the portfolio was to combine the concept of a portfolio and a presentation into one, using the Internet and multimedia as a competitive atmosphere. The photos of athletes symbolize the competition of the Internet. The creative verbiage stresses the competitive advantage of using the Internet to reach potential clients. Statistics and facts about domains and Internet use are flashed before one's eyes. The viewer is told that "Running with the pack is not enough." This Flash Portfolio is used for presentations on a laptop. The idea (light bulb) theme runs through to the end of the flash presentation, ending with "Ideas Matter."

FLASH PORTFOLIO DESIGN
DESIGNER **Brent Hollingsead, Information Artist**
COPY WRITING **Zan Turvey, Principal**

Web Presence
Networking, LLC

83% of IT Managers
recognize that the
Internet provides a
competitve advantage.

Web Presence
Networking, LLC

Worldwide Internet
Commerce will
reach as high as
$3.2 trillion in 2003

Web Presence
Networking, LLC

RUNNING WITH THE PACK...

ISN'T ENOUGH.

DREAMLIGHT STUDIOS

DREAMLIGHT STUDIOS' DIGITAL PORTFOLIO DEVELOPED OVER THE COURSE OF MANY YEARS. WHILE CREATING ALL SORTS OF DIGITAL MEDIA FOR OVER A DECADE, THE FIRM WAS VERY CAREFUL ABOUT RETAINING THE RIGHTS TO USE ALL ITS IMAGES FOR PROMOTIONAL PURPOSES. THIS RESULTED IN A HUGE LIBRARY OF AWARD-WINNING DIGITAL SAMPLES. DREAMLIGHT COLLECTED SOME OF ITS MORE INTERESTING PROJECTS AND CREATED THE DREAMLIGHT VIRTUAL GALLERY. THIS IS A CONSTANTLY EXPANDING COLLECTION OF SAMPLES ON DISPLAY. THE FIRST PAGE OF THE GALLERY IS THE SPOTLIGHT EXHIBIT, WHERE NEW PROJECTS ARE SHOW-CASED BEFORE RELOCATING THEM TO THE APPROPRIATE SECTIONS WITHIN THE GENERAL GALLERY. THE DREAMLIGHT VIRTUAL GALLERY IS THE MAIN FOCAL POINT OF THE ENTIRE WEB SITE AND A MAJOR DRAW TO WEB SURFERS.

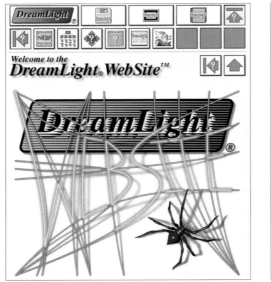

DreamLight Studios homepage is designed in the cool tones of purple, blue and black against a white and gray background. The web site draws on a "web" theme with a spider web and spider in purple. The icon buttons on top direct the viewer to the various sections of the site, including the gallery section, which is designated by a picture frame icon. Those interested in the design techniques of the web site, from navigational structure to the HTML layout and content, can view a special section called DreamLight Spotlight Exhibits.

CLIENT **DreamLight Incorporated Website**
DESIGNER **Michael Scaramozzino**

DreamLight's Virtual Gallery opening page has an illustration of "Nino," a purple animated creature walking through a gallery on a path to the window. The cool tones of the home page carry over to this gallery page.

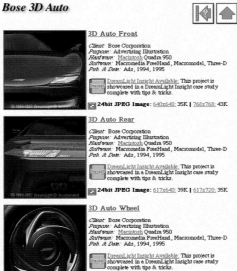

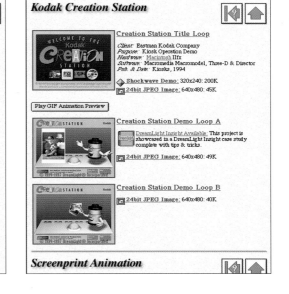

Viewers are able to view thumbnails of each of the design pieces to follow. By clicking on a thumbnail, the piece enlarges, and detailed information about the piece, including the client, purpose, hardware, software, date and size, and type of image appears.

Bose Corporation wanted a fictional sports car designed from scratch to serve as the centerpiece for an international ad campaign. The Bose 3D Auto was selected to be part of the Illustration West 33 Exhibition at the Pacific Design Center in West Hollywood, California, where it won a certificate of merit. The piece also won the 1994 Optima Design Awards Certificate of Outstanding Achievement in recognition of outstanding creative achievement in the field of graphic arts.

CLIENT **Bose Corporation**
DESIGNER **Michael Scaramozzino**

DreamLight created a demo for the new Kodak Creation Station kiosk multimedia tutorial. The Creation Station feeds in photographs—prints, slides, and negatives—and allows for alterations including cropping, zooming, rotating and more. The piece uses a full color palette to represent the many colors of Kodak. Macromedia FreeHand was used due to the exceptional object oriented design capabilities. DreamLight created "Snapshot," a new character, in Macromodel, the precursor to Macromedia Extreme 3D. Choosing a color for the character was easy— "Kodak yellow."

CLIENT **Eastman Kodak Company**
DESIGNER **Michael Scaramozzino**

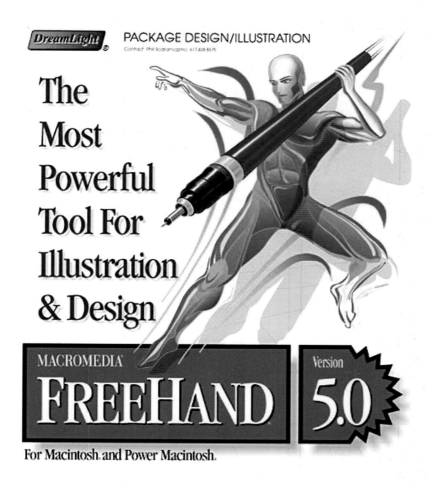

When Macromedia acquired Altsys Corporation and the rights to FreeHand, they wanted a redesign package identity for the high profile introduction of the new FreeHand 5. Requirements included a red box at the bottom left with the product name, a large scale positioning statement running down the left side, and a bold graphic figure to command the viewer's attention on the right side. DreamLight introduced the javelin thrower, an image sure to catch the eye. The cool tones against a white background on the package continue throughout the software in the various icons.

CLIENT **Macromedia**
DESIGNER **Michael Scaramozzino**

SKOLOS-WEDELL, INC.

REPEATED ELEMENTS IN THIS WEB PORTFOLIO STRENGTHEN
SKOLOS-WEDELL'S IDENTITY. META, THE PRIMARY FONT, IS
TAKEN FROM ITS PRINTED STATIONERY AND BUSINESS
CARDS. THE GREEN STRIPES ECHO SKOLOS-WEDELL'S PRINT-
ED PROMOTIONAL BROCHURE, BUILDING A CONSISTENT
LOOK FOR COMPANY IDENTITY. THE WEB PORTFOLIO STRUC-
TURE IS HORIZONTAL, WITH A DIVISION BETWEEN TOP AND
BOTTOM. THE FIRM DIDN'T WANT TO CLASH WITH ITS COLOR-
FUL DESIGN PIECES DISPLAYED IN THE BOTTOM FRAME, SO IT
CHOSE A BACKGROUND OF BLACK, WHITE, OR GRAY. AS FOR
THE TYPOGRAPHY, THE GESTURES AND TYPE MIRROR THE
BOTTOM FRAME. UNLIKE MOST PORTFOLIOS, SKOLOS-WEDELL
INCLUDES ITS CREATIVE PROCESS AND PHILOSOPHY, AMONG
OTHER THINGS. THE PORTFOLIO IS MORE FINE-ART ORIENT-
ED, MORE INFORMATIONAL. IT WAS NOT DESIGNED WITH A
SALES OR MARKETING APPROACH, BUT RATHER A MORE
SUBTLE EFFECT.

The white triangle with green stripes found on the opening page is a common thread throughout the site. Any time the viewer wishes to navigate backward, he/she must locate the triangle and click on it. The green stripes also tie into the corporate identity of the firm and can be found on other promotional materials.

The white background of the home page is in stark contrast to the black of the opening page. Green horizontal stripes continue on the top of the screen, with a collage of images and typography on the bottom. The firm's name and address is scattered around the bottom.

WEB SITE DESIGN
ART DIRECTOR **Nancy Skolos**
DESIGN **Davis Stanard**
TYPOGRAPHY **Eduardo Monreal**
PROGRAMMING **Donald Russell of Fudge
Web Development**

The collage breaks into pieces before the viewer's eyes, and the green stripe motif moves to the bottom of the page. Each piece represents a type of design work, including corporate identity, book design, corporate posters, product photography, exhibit design, brochure design, cultural posters and typographic posters. Nancy Skolos and Thomas Wedell are pictured on top.

Viewers can locate the type of design work they wish to see by holding the mouse over a particular piece. Deciding on the pieces to feature in each portfolio section was difficult, as the firm had over 20 years of work to consider.

One of the firm's specialties is product photography. Photographer Thomas Wedell uses many different light sources to render a three-dimensional form of a small product.

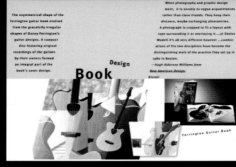

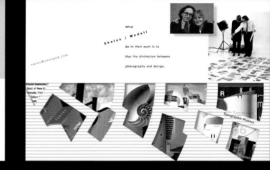

The Ferrington Guitar Book is asymmetrical in shape, in keeping with the asymmetrical shapes of Danny Ferrington's guitars. Warmer colors of yellows, tans and browns draw on wood tones. Using enhanced animation, page spreads rotate, giving the viewer an inside look at the book.

By clicking on a category of design, an example of the design work appears. Soon after, a triangular part of the image breaks off and travels to another point on the page. This triangle traveling across the page keeps the eye moving and the mind wondering.

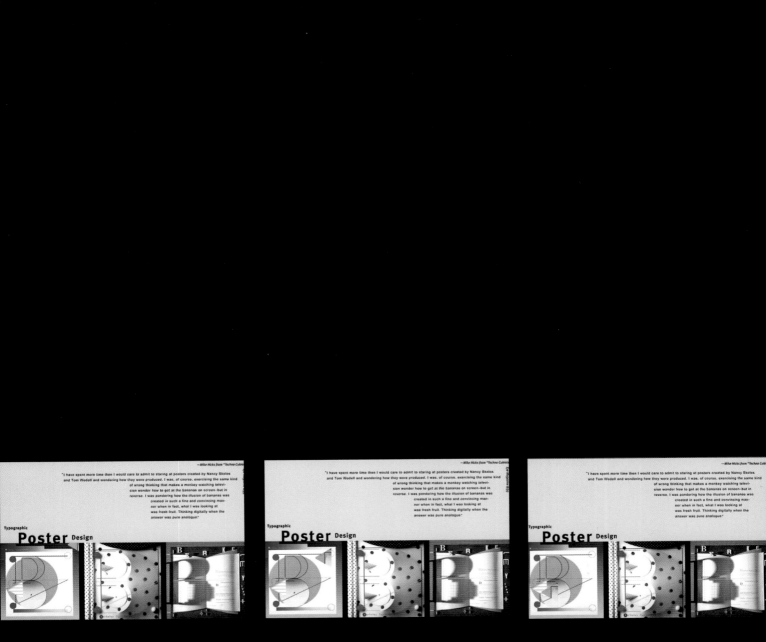

Typographic posters feature collage images to
enhance the typography. These three poster views
of the Berkeley typography are designed in cool tones
of purples and blues.

CLIENT **Berkeley Typographers**
DESIGNERS **Nancy Skolos, Thomas Wedell**
PHOTOGRAPHER **Thomas Wedell**

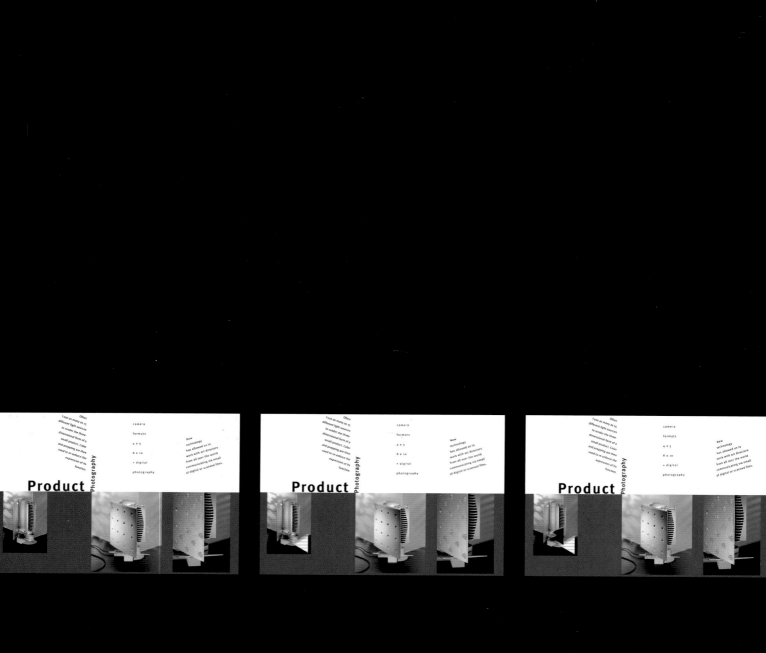

The Skolos-Wedell web site portfolio was designed with a horizontal split between the top and bottom of the page. The colors on top are neutral, so as to not clash with the design pieces on the bottom of the page. This personal fan is a product of Details, a Division of Steelcase Design Partnership. The colors in this product photography piece are the cool tones of greens and blues against a black background.

CLIENT **Details, a Division of Steelcase Design Partnership**
DESIGNERS **Nancy Skolos, Thomas Wedell**
PHOTOGRAPHER **Thomas Wedell**

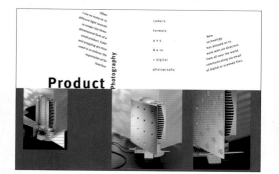

Skolos-Wedell, Inc.
529 Main St.
Charlestown, MA 02129
617-242-5179
617-242-2135 fax
swinc@skolos-wedell.com

technology partners

ViSiT

As the viewer exits the Skolos-Wedell web site
portfolio, the background switches back to the black
background. Contact information is displayed, and
the viewing comes to an end.

THE SWISH GROUP LIMITED

THE SWISH GROUP LIMITED OF AUSTRALIA EXTENDED ITS CORPORATE IDENTITY IN THE DESIGN OF ITS WEB PORTFOLIO. THE CORPORATE COLOR IS BLUE WITH YELLOW INTRODUCED FOR A FUTURE FEATURE, AS WELL AS TO ADD CONTRAST. THE WHITE BACKGROUND MAKES IT EASY TO READ AND PRINT. THE PORTFOLIO SECTION, PRESENTED UNDER "CASE STUDIES," WAS DESIGNED TO BE A SELF-CONTAINED UNIT, MAKING THE PROJECTS THE MAIN FEATURE. THE FIRM SPECIALIZES IN CD-ROM, CORPORATE IDENTITY, WEB SITE DESIGN, AND PRINT WORK. HERE THE BLUE BACKGROUND ADDS COLOR WITHOUT TAKING OVER THE FEATURED PROJECT. THE WEB PORTFOLIO HAS A SENSE OF DESIGN AND STRUCTURE, YET DOWNLOADS QUICKLY FOR THOSE TIME-STARVED VIEWERS.

The Swish Group Limited features design work in the Case Studies section of the web site. Categories include CD-ROM, corporate identity, web site design, and print. The index remains a constant in the portfolio in the upper right of every page. Thumbnails of the various design pieces are contained below the opening page of the various design categories.

The CD-ROM has the potential to entertain, involve, and instruct. The viewer interaction with the program is integral to the medium.

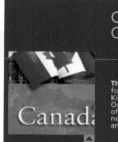

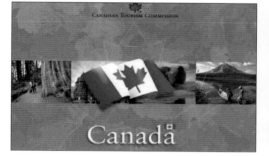

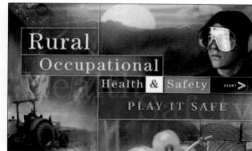

The Swish Group was invited to pitch for the Canadian Tourism Commission kiosk project in Singapore. Through this project, the firm showed its ability to undertake large-scale new media projects outside of Australia.

CLIENT **Canadian Tourism Commission**

This interactive multimedia introduction to occupational health and safety issues on farms is called "Play It Safe." It was intended for farm operators, workers, and anyone else interested in farm safety.

CLIENT **Sunraysia Tafe**

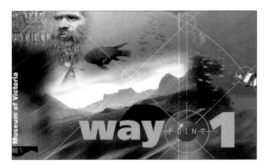

The branding of an organisation is part of its image. A company image is made up of all aspects of how a company portrays itself to the outside world. The graphic symbolism of a company mark, therefore comes to represent that companies personality.

Musashi

MUSASHI

A brand for a range of health supplements including amino acids. The design has a deliberate Japanese or Asian feel as the products are linked to eastern remedies. The brand has established a secure position in the healthy lifestyle market place.

Waypoint 1 was produced for the Museum of Victoria to present Victoria's social, ecological, and natural history in a graphically vibrant, interactive environment. This two-disk CD-ROM title offers twelve interactive worlds to explore.

CLIENT **Museum of Victoria**

The branding of an organization is part of its image. A company image is made up of all aspects of how a company portrays itself to the outside world.

Musashi is a brand for a range of health supplements that are linked to eastern remedies. The firm gave the design a deliberate Asian feel to enhance appeal.

CLIENT **Musashi**

Ocean Internet

An identity for an internet service provider. The combination of the letter ' O' with symbolism of waves for the sea in a high tech style.

Print is a powerful and versatile medium. The combination of graphics, images, colour and the aesthetics of fine paper all contribute to the written word.

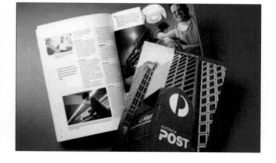

The Swish Group designed an ocean wave effect for this Australian Internet service provider. The company used a combination of the letter "O" with symbolism of waves for the sea.

CLIENT **Ocean Internet**

Print is a powerful and versatile medium. The combination of graphics, images, color, and the aesthetics of fine paper all contribute to the written word.

Today an annual report is often a marketing document as well as a statement on an organization's financial position. The cover of this annual report featured Australia Post's new corporate identity.

CLIENT **Australia Post**

A web site has to be in sync with a companies image and marketing strategy. It is no longer good enough to have a web site conceived in isolation. Cute graphics are not enough.

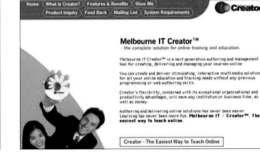

One of the largest print runs in the country is the Amcor annual report. Since many different types of people view this report, the challenge is in serving the needs of the cursory reader as well as the stock market analyst.

CLIENT **Amcor**

A web site has to be in sync with a company's image and marketing strategy. It is no longer good enough to have a web site conceived in isolation.

Designed in conjunction with the official launch of the Creator Software, the web site provides access to product information and reflects the product branding.

CLIENT **Creator Software**

The Sydney Design 99 web site was built to showcase
the Sydney design conference. The site utilizes Flash
animation to deliver an interactive experience.

CLIENT **The Sydney Design 99**

BE AWARE OF WHERE THE EYE IS LED.

AS THE PAGE DOWNLOADS AND THE PIXELS COME INTO FOCUS, YOU'RE ON STAGE. YOUR CAPTIVE AUDIENCE— A POTENTIAL CLIENT—EXPECTS YOU TO PUT ON A GOOD SHOW. SO HOW ARE YOU GOING TO WOW THEM?

FIRST OFF, THINK OF YOUR PORTFOLIO AS A FORM OF ENTERTAINMENT. IT'S YOUR JOB TO CAPTURE THE VIEWER'S ATTENTION, KEEP IT, AND MAKE THE VIEWER WANT EVEN MORE. IT'S A BIT LIKE TELLING A STORY. HOW YOU TELL IT MAKES ALL THE DIFFERENCE.

TRY PUTTING YOURSELF IN THE VIEWER'S SEAT. WHAT GRABS YOUR ATTENTION? IS IT WARM OR COOL COLORS? FONTS? ANIMATION? SPEED? OR A COMBINATION OF THESE?

THERE ARE MANY WAYS TO MAKE YOUR PORTFOLIO MEMORABLE. SHARP AND VIBRANT IMAGES ARE KEY. MAKE SURE YOUR OFFERINGS INCLUDE THE FULL EXTENT OF YOUR DESIGN CAPABILITIES. CREATE EASY TO READ AND INFORMATIVE COPY TO SUPPORT YOUR DESIGN WORK. KEEP IT QUICK–EASY TO DOWNLOAD AND EASY TO NAVIGATE. AND ADD A LITTLE SPICE WITH ANIMATION OR SOUND EFFECTS.

Evocative statements go a long way. Questions keep the viewer wondering. Words are one of the best ways to capture attention. Use a voice that conveys excitement, a thrill, anything that will strike a chord. Focus on the most powerful aspect of your imagery and feature it up front. Let the viewer taste the real flavor of your design style right from the start.

COLORS CAN BOTH ATTRACT AND DISTRACT, DEPENDING ON YOUR DESIGN STRATEGY. BALANCE IS CRUCIAL. OVERSTIMULATION CAN WORK AGAINST YOU. ON THE OTHER HAND, A MONOCHROME PORTFOLIO CAN BE QUITE DULL. AN UNUSUAL AND INVIGORATING COMBINATION OF COLORS TENDS TO CAPTURE ATTENTION; COOL TONES CAN ACHIEVE A SIMILAR EFFECT IN THE RIGHT SITUATION. THE USE OF COLOR IS IMPORTANT, BUT NOT UNIVERSAL. BLACK-AND-WHITE PORTFOLIO DESIGNS HAVE STRENGTH IN CONTRAST AND CAN BE QUITE DRAMATIC AS WELL.

WHETHER IT'S LOGOS, NAVIGATION TOOLS, OR OTHER IMAGES, THE USE OF ANIMATION IS CERTAIN TO ENTER-TAIN. LET YOURSELF GO. CREATE SOME ACTIVITY THAT IS CERTAIN TO CATCH THE EYE. ANIMATION ALLOWS YOU TO TELL A STORY. IT ACHIEVES A SENSE OF MOTION. IT'S ALSO A FUN WAY TO LURE THE POTENTIAL CLIENT IN THE DIRECTION YOU WANT HER TO GO.

ATTE NTION

Animation provides a dimension of interactivity. It's not static. It allows a potential client to actively participate in the review process, not just click through. It's also the perfect platform to show off 3-D rendered images. Viewers get a kick out of opening and closing a package or brochure. Toss in some music or sound effects, and the viewer will be happily entertained.

Creativity can take on an infinite number of shapes. So if you're not into clever wizardry, there's always the simple approach. A look that is strong, confident, and understated will allow your design work to take center stage. Since those who view your portfolio will be looking at many aspects, pragmatic soundness is just as important as your wilder creative impulses. Plus, providing a clean and simple portfolio design will put the potential client at ease. Confusion and lost time

will be kept to a minimum. Remember that trying to figure out ambiguous navigation buttons and directions can be frustrating. Also, downloading complex images can take forever. On the web, a simple presentation is a fast presentation. In a time-starved society, that's worth quite a bit.

It's true, you need a dramatic impact to distinguish yourself from others. But don't confuse the medium with the message. Don't become overly enchanted with what technology has to offer. Zero in on your strengths, and put them in the forefront. Be clear, articulate, and unambiguous. Clearly mark navigation buttons. Don't create confusing image mapping. Ensure fast download time. Animation and sound effects are an added bonus. And above all, don't forget to entertain.

EAT ADVERTISING AND DESIGN, INC.

WHEN EAT ADVERTISING AND DESIGN, INC., PUT TOGETHER A DIGITAL PORTFOLIO, THE FIRM WAS PITCHING A COMPANY FOR SOME DESIGN WORK. SINCE THE WORK FOR THIS POTENTIAL CLIENT COULD LEAD TO WEB DESIGN, THE FIRM DECIDED TO PUT ITS OWN PORTFOLIO TOGETHER IN ORDER TO HAVE A PRESENCE. EAT'S WEB PORTFOLIO USES THE SQUARE FORMAT GRID PATTERN. THEY RETAINED THE ORIGINAL FONTS USED WITHIN THE DESIGN PIECES. IN THE SPECIALTY AREAS, THE FIRM USED EASY-TO-READ SANS SERIF FONTS THAT TRANSFERRED WELL TO THE WEB. BLACK, RED, AND WHITE REFLECT THE CORPORATE COLORS AND CORPORATE IDENTITY. THE BLACK BACKGROUND DOESN'T DETRACT FROM THE DESIGN PIECES DISPLAYED. IT PREVENTS CLASHING WITH IMAGES ALREADY PRINTED.

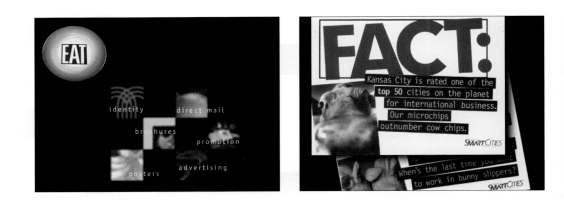

The EAT Advertising and Design, Inc., web portfolio goes straight to the goods. The clean, black home page with EAT's red and white logo in the upper left features squares of screened design pieces in various categories including identity, direct mail, brochures, promotion, posters, and advertising. Clicking on one of the squares brings the viewer to a specific section that contains between six and ten samples.

Smart Cities is a Kansas City area development organization that markets the city to potential businesses and events. The firm used the close-up of a cow face along with clever copy to enhance the piece.

CLIENT **The Kansas City Area Development Council/Smart Cities**
DESIGNERS **Patrice Eilts-Jobe, Kevin Tracy, Toni O'Bryan**
PHOTOGRAPHER **Tatjana Alvegaard**

Downtown Import Service enlisted EAT to do some heavy-duty identity work. The company is involved in servicing, parts, and sales of import cars. EAT designed this direct mail piece to introduce that Downtown Import Service had received Honda accreditation.

CLIENT **Downtown Import Service, Inc.**
DESIGNERS **Patrice Eilts-Jobe, Toni O'Bryan**

This multicolored brochure fittingly announces the four-color printing capabilities of PrintTime, a small specialty printer. The brochure was one in a series that talked about the company's various services and capabilities.

CLIENT **PrintTime**
DESIGNERS **Patrice Eilts-Jobe, Kevin Tracy, Paul Prato**
PHOTOGRAPHER **Steve Curtis**

This poster was designed for the Gas Service Division of Western Resources, Inc., a utilities company that services Kansas and parts of Missouri, Oklahoma, and Nebraska.

CLIENT **Western Resources, Inc.**
DESIGNERS **Patrice Eilts-Jobe, William McMillian**
ILLUSTRATOR **Michael Weaver**

EAT "branded" the Cattle Crawl for the past four years with promotional pieces such as posters, brochures, recipe cards, and T-shirts. The Cattle Crawl is an annual event sponsored by the Kansas Beef Council to promote beef.

CLIENT **Kansas Beef Council**
DESIGNERS **Patrice Eilts-Jobe, Paul Prato**

EAT Advertising designed this logo for Houlihan's, part of Houlihan's Restaurant Group. Houlihan's is the most franchised of the group's offerings, which include seafood and beef restaurants as well.

CLIENT **Houlihan's Restaurant Group for Houlihan's**
DESIGNERS **Patrice Eilts-Jobe, Kevin Tracy, Paul Prato**

This logo was designed to show equal representation of the two divisions of Theis Doolittle Associates, Inc., an architecture and landscape architecture firm. EAT worked to portray the fusion of the two disciplines in the design of the logo.

CLIENT **Theis Doolittle Associates, Inc.**
DESIGNERS **Patrice Eilts-Jobe, Toni O'Bryan**
ILLUSTRATOR **Michael Weaver**

EAT designed the packaging for this brand of
roasted pumpkin seeds. In Mexico, special pumpkin
seeds, pepitas, are harvested purely as a snack food.
The seeds are a cross between a sunflower and a
pumpkin seed.

CLIENT **Nita's Packaging—Wendell Anschutz**
DESIGNERS **Patrice Eilts-Jobe, Toni O'Bryan**
ILLUSTRATOR **Toni O-Bryan**

DIETZ DESIGN, CO.

THE DIETZ DESIGN WEB PORTFOLIO CAPTURES ATTENTION IMMEDIATELY BY TELLING THE VIEWER WHERE HE IS–"YOU ARE HERE." PART OF THE GOAL WAS TO SHOW THAT DIETZ DESIGN HAD A SENSE OF HUMOR AND THAT IT DOESN'T TAKE ITSELF TOO SERIOUSLY, WHILE USING THE DESIGN TO SHOW THAT IT DOES TAKE THE RESULTS AND PROCESS SERIOUSLY. THE SIM-PLIFIED STATEMENTS AND SEMANTICS USED THROUGHOUT THE WEB PORTFOLIO CAUSE A VIEWER TO PAUSE.

THE FIRM WANTED THE PORTFOLIO TO BE CONSISTENT WITH THE FIRM'S IDENTITY AND OTHER MARKETING TOOLS, SO IT UTI-LIZED COLORS AND FONTS FROM EXISTING MATERIALS. THE GREEN/GRAY COLOR IS USED BOTH ON PRINT COLLATERAL AND IN THE FIRM'S OFFICES. THE GRAPHICS FOR EACH OF THE TOPIC AREAS WERE CREATED TO HELP ILLUSTRATE THE COPY TONE. FOR EXAMPLE, THE COPY UNDER THE IDENTITY SECTION OF THE PORTFOLIO "UNLESS YOU ARE A CRIMINAL, A RECOGNIZABLE IDENTITY IS ALWAYS AN ASSET" USES ROBERT DIETZ'S THUMB-PRINT TO ACCENTUATE THE VISUAL PLAY OF TYPE VERSUS IMAGE.

Dietz Design makes it clear to potential clients that it's not a typical design firm. Entertaining and clever copy, along with the bull's-eye against a white background, attract attention.

Dietz Design offers several categories of design work for review, including collateral, interactive, identity, packaging, and advertising. The small type below the arrow directs the viewer to choose a category—"now go there".

The thumbprint is principal Robert Dietz's own. Playing off the identity theme, the thumbprint contains five small circles representing design pieces. When the viewer clicks on one, a large view of the piece appears, while a small version of the thumbprint remains at the top of the page.

Dietz Design developed an identity for Edgeworks, an outdoor equipment manufacturer. The Armadillo by Walrus logo features a blue armadillo with black and blue type.

CLIENT **Edgeworks (A subsidiary of REI)**
ART DIRECTOR **Robert Dietz**
DESIGNER **Dannielle Moilanen**

Shopping online has become increasing popular due to its convenience. When Cendant Software decided to provide an online shopping service, Dietz Design was enlisted to create the brand identity. The logo of vibrant colors—orange, blue, and green—pictures a fluid figure carrying a shopping bag.

CLIENT **Cendant Software**
ART DIRECTOR **Robert Dietz**
DESIGNER **Kristie Severn**

The packaging section features a box on the index page listing Adobe, Imation, Robert Vaughn, PhotoDisc, and Software Architects as examples. This box also appears on the top of each packaging page. By clicking on Robert Vaughn, the viewer is able to see the CD, jacket, and other printed materials for Robert Vaughn's CD.

CLIENT **Miramar Recordings**
DESIGNER **Robert Dietz**

PhotoDisc sells copyright-free stock photography on CD-ROM and over the Internet. Dietz Design created several components, including the user manual, CD-ROM design, and jacket design for PhotoDisc.

CLIENT **PhotoDisc**
ART DIRECTOR **Robert Dietz**
DESIGNER **Kristie Severn**

The open briefcase contains collateral for Imation, Luminous, Nordstrom, Text100, and University Village. This section stresses the importance of communicating to your audience in order to be noticed (and not discarded). Text100 is a technology public relations firm.

CLIENT **Text100 Public Relations**
DESIGNERS **Robert Dietz, Denis Heckman**
ILLUSTRATOR **Doug Herman**

Addressing the challenge of download speed is most appropriate in the interactive section. Featured is a laptop computer on top with examples of CD-ROMs, web sites, and online magazines. This Mozart CD-ROM interface was created for Sunhawk Music Publishing.

CLIENT **Sunhawk Music Publishing**
DESIGNER **Kathy Thompson**

Dietz Design came up with a conceptual design for a web site for Sierra Online, a division of Cendant Software, a software game company. The woman in the middle of the screen invites the viewer to play by selecting one of the buttons in front of her.

CLIENT **Cendant Software**
DESIGNER **Robert Dietz**

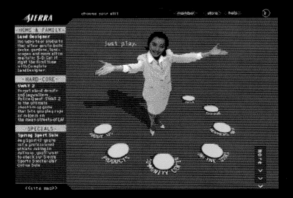

LAUGHING DOG CREATIVE, INC.

IN TRYING TO CATCH A CLIENT'S ATTENTION, LAUGHING DOG CREATIVE HAD ONE OBJECTIVE—TO ENTERTAIN. THE FIRM WANTED THE VIEWER TO WALK AWAY WITH A SENSE OF ITS PERSONALITY, INTERESTS, AND TYPE OF EMPLOYEES. LAUGHING DOG CHOSE TO MAKE THE WEB SITE A LITTLE MORE JAZZY AND COMPLICATED, SINCE ITS CLIENTS TEND TO BE MORE HIGH-TECH ORIENTED. THE PORTFOLIO SECTION IS CALLED THE DOGHOUSE, PLAYING ON THE COMPANY NAME. IT INCLUDES A WIDE VARIETY OF DESIGN WORK SUCH AS PROGRAMS, LOGOS, COLLATERAL, PACKAGING, AND ADVERTISING. ONCE A VIEWER IS FINISHED WITH THE "SERIOUS STUFF," THE GIZMO SECTION PROVIDES AN ADDED DOSE OF ENTERTAINMENT, INCLUDING A SNOW DOME COLLECTION, JIGSAW PUZZLES, AND T-SHIRTS.

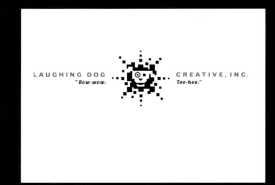 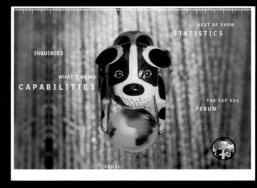

The white background of the web portfolio was intended to enhance viewing. The site has some elements of the corporate identity, including the orange-red and black highlights.

The metal wind-up dog holding the earth is a spin-off of the Greek god Atlas. The firm was looking for a cheesy image that would make viewers smile. The blue background has a "Vegas" look. The background humming is designed to get the viewer off the home page as quickly as possible, or become highly annoyed.

The Doghouse gives a description of the firm with a list of services, including programs, logos, collateral, packaging, advertising, and "stuff," which is a catchall of work.

After Laughing Dog designed an introductory piece for the McDonald's Center for Corporate Training Identity, the client asked the firm to develop the identity as well. To the firm's amazement, McDonald's chose this solution even though, at the time, the logo broke the rules established by its graphic standards.

CLIENT **McDonald's Corporation**

This logo was designed for a small suburban company that focused on developing new ideas and directions for national consumer products companies.

CLIENT **Galileo Idea Group**

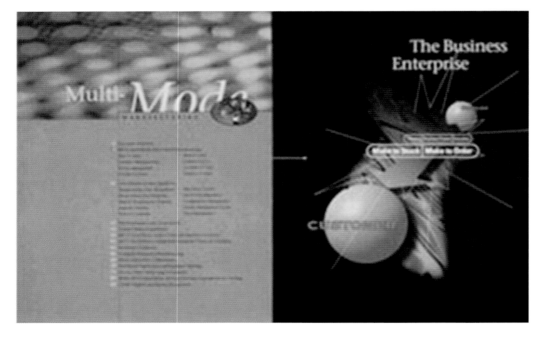

The SSA Level 1 brochures were designed and produced in less than ten weeks. This series of brochures has become the standard style for this national AS/400 software development company.

CLIENT **System Software Associates, Inc.**

Pictured are two of four holiday gift boxes designed for a Chicago-based distributor. The only parameter was that Laughing Dog incorporate the products' label onto the outside package. The Imperial box was an award winner.

CLIENT **Barton Brands**

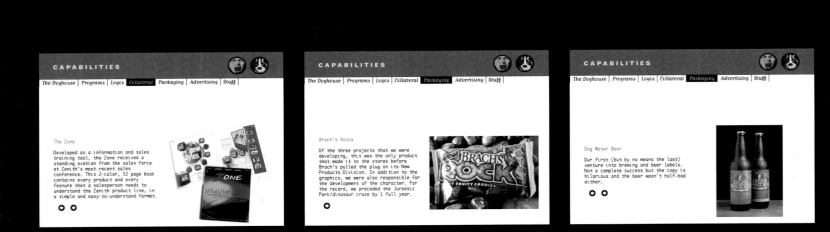

Developed as an information and sales training tool, the Zone, a two-color, 52-page book, contains every product and every feature that a salesperson needs to understand the Zenith product line, in a simple and easy-to-understand format.

CLIENT **Zenith Electronics Corporation**

Laughing Dog was responsible for the development of the character for Brach's Rocks as well as the unique graphics. For the record, the firm preceded the Jurassic Park/dinosaur craze by one full year!

CLIENT **E.J. Brach Corporation**

This was Laughing Dog's first (but by no means last) venture into brewing and beer labels. Though not a complete success, the copy was found to be hilarious and the beer not bad.

CLIENT **Laughing Dog Creative, Inc.**

CAPABILITIES

The Doghouse | Programs | Logos | Collateral | Packaging | Advertising | Stuff

The 1998 Lincoln Park Zoo Ball

Although this was our eighth (!) time
designing materials for the Zoo's largest
fundraiser, it was our first time working
with producer/coordinator extraordinaire
Donna La Pietra. How could we possibly match
the enthusiasm and creativity of one of
Chicago's true visionaries? I'd like to
think we came close.

CAPABILITIES

The Doghouse | Programs | Logos | Collateral | Packaging | Advertising | Stuff

The Lincoln Park Zoo Balls

The Lincoln Park Zoo Ball invitations are
one of the more entertaining projects
that we're associated with. The Zoo Ball
is the Zoo's largest annual fundraiser
and we're proud that we're invited back
year after year to contribute.

CAPABILITIES

The Doghouse | Programs | Logos | Collateral | Packaging | Advertising | Stuff

A Very Tuffy Xmas

Probably our most famous
self-promotion to date, this
"card" tells the holiday story
of Tuffy and his untimely
encounter with fruitcake.
Sick, twisted and funny...just
the way we like it!

The Stuff section contains examples of invitations,
cards, and event pieces. Invitations are one of the
more entertaining projects that Laughing Dog is
associated with. One such invitation featured is for
The Lincoln Park Zoo Ball, the zoo's largest fundraiser.

CLIENT **The Women's Board of Lincoln Park Zoo**

Probably the firm's most famous self-promotion to
date, this card tells the holiday story of Tuffy and
his untimely encounter with fruitcake. Laughing Dog
claims the piece to be sick, twisted, and funny—
just the way they like it.

THE MAVIYANE-PROJECT

THE DARK OPENING PAGES OF THE MAVIYANE-PROJECT OF ZIMBABWE'S PORTFOLIO STRIVE TO SET THE TONE FOR EVERYTHING THAT FOLLOWS. THE BLURRED CLOSE-UP BACKGROUNDS PROVIDE AN ELEMENT OF MYSTERY, WHILE A SENSE OF SPIRITUALITY IS ADDED WITH THE BURNING SHIELDS ICONOGRAPHY. SHIELDS IMPLY DEFENSE AND DEFIANCE—IN THIS CASE OF THE MAVIYANE-PROJECT WORK AND CULTURE.

WHEN YOU GET TO THE IMPORTANT ATELIER SECTION, THE THUMBPRINTS WHET THE APPETITE ENOUGH TO SEE THE FINAL IMAGES AND THEIR EXPLANATIONS. WHAT IS PERHAPS MOST SIGNIFICANT ABOUT THIS PORTFOLIO IS THAT THE WORK IS DIVIDED INTO SOCIAL CATEGORIES INSTEAD OF ACTUAL TYPES OF DESIGN WORK. THESE CATEGORIES ARE HUMAN RIGHTS, SOCIAL & ENVIRONMENT, AND EPHEMERA.

A CLEAR SAN SERIF FONT (THESIS) IS USED THROUGHOUT THE SITE SO AS NOT TO COMPETE OR DILUTE THE IMAGERY, WHICH IS THE PARAMOUNT REASON FOR THIS PORTFOLIO.

Chaz Maviyane-Davies feels it is important to help combat the negative portrayals of Africans that exist, that everything they do is third-rate. Hence the use of the word Dignity in the opening page—someone with his destiny in his own hands.

Being from a developing nation on a continent described as the "Heart of Darkness," the Internet has provided Maviyane-Davies the opportunity to display his creative vision and skills on an international electronic gallery.

The Human Rights selection features a screened face in the background, making the viewing a personal experience. Carefully placed thumbnails attract the viewer's curiosity.

These posters are from a series entitled RIGHTS that was established to bring awareness to human rights. They are made available through Amnesty International to human rights groups, schools, social institutions, galleries, and anyone who feels they can use them to further the cause of human rights throughout Africa and elsewhere. This poster shows a flag of the Zimbabwean national colors concealing a face. The poster is meant to convey that everyone has the right to a nationality and to change it.

CLIENT **The Maviyane-Project**
DESIGNER **Chaz Maviyane-Davies**
PHOTOGRAPHER **Ian Murphy**

Article number 21 states that everyone has the right to vote. The X across the face represents making a choice. Through an X on the ballot paper, we reveal ourselves.

CLIENT **The Maviyane-Project**
DESIGNER **Chaz Maviyane-Davies**
PHOTOGRAPHER **Ian Murphy**

Maviyane-Davies focuses mainly on the more powerful aspect of his imagery in the portfolio, especially topics involving social awareness. The fist in the background evokes a feeling of fighting in order to survive.

Everyone has the right to freely participate in the cultural life of the community and to enjoy the arts. A film reel featuring children in traditional adornments runs across the chest.

CLIENT **The Maviyane-Project**
DESIGNER **Chaz Maviyane-Davies**
PHOTOGRAPHER **Rolf Varga, Howard Burditt, Photobank (Harare)**

These posters were developed for Cimas, a medical aid society, to support people suffering from AIDS. The X-ray effect and use of positive and negative light attract attention.

CLIENT **Cimas**
DESIGNER **Chaz Maviyane-Davies**
PHOTOGRAPHER **Chaz Maviyane-Davies**

Maviyane-Davies combines the use of photography and graphic design to create a captivating poster. The names of many diseases, including AIDS, are screened across a chest to convey the point that we are all equal regardless of race, color, sex, religion, or illness.

CLIENT **Cimas**
DESIGNER **Chaz Maviyane-Davies**
PHOTOGRAPHER **Ian Murphy**

This poster was developed for exhibition during the 2nd UN Conference on the Environment in 1992. The concept of Mother Earth is achieved by the screening of a tree across a mother feeding a baby.

CLIENT **Design Rio Promotion Centre**
DESIGNER **Chaz Maviyane-Davies**
PHOTOGRAPHER **Rolf Varga**

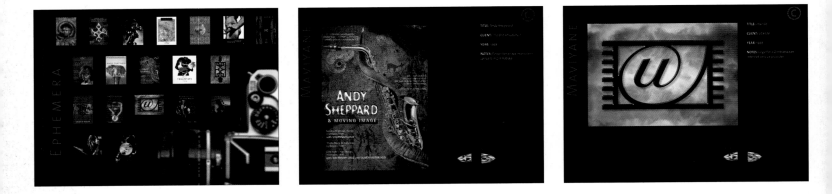

The Ephemera section features types of work having a short life, including books, magazine articles, and logos.

This poster was designed for a concert in Zimbabwe performed by jazz musician Andy Sheppard. Sheppard played along with Savannah Cruz and Oliver Mutukudzi. The petroglyphs in the background and the oranges and browns convey the spirit of Africa. The saxophone is entwined with a Kudu Horn, a traditional musical instrument played by blowing through the narrow end.

CLIENT **The British Council**
DESIGNER **Chaz Maviyane-Davies**
PHOTOGRAPHER **Bob Davey, Ian Murphy**

Utande is an Internet service provider in Zimbabwe. The prominent logo has oranges and yellows reminiscent of African skies behind a black "u".

CLIENT **Utande Internet Services**
DESIGNER **Chaz Maviyane-Davies**

KANDAYA

Another Time, Another Place

ANGUS SHAW

This red book cover with cutout letters combines
the use of photography with graphics. Kandaya
Another Time, Another Place by Angus Shaw is a story
about an African freedom fighter. Kandaya was an
elusive guerilla during the struggle for Zimbabwean
independence between 1975 and 1980.

CLIENT **Baobab Books**
DESIGNER **Chaz Maviyane-Davies**
PHOTOGRAPHER **Calvin Dondo**

NVISION DESIGN, INC.

WHEN NVISION DESIGN, INC., CREATED ITS WEB PORTFOLIO, THE FIRM WANTED TO PROVIDE MORE THAN A MERE IMAGE OF ITS DESIGN WORK. WITH THE ADVANCED FUNCTIONALITY OF THE SITE, CLIENTS CAN VIEW ADDITIONAL INFORMATION BY SELECTING COLORED BUTTONS. BUTTON "E" (ENHANCED) SHOWS ENHANCED ART OF THE SAMPLE, INCLUDING ANIMATIONS, ENLARGEMENTS, AND ADDITIONAL VIEWS. THE "A" (AWARD) POP-UP WINDOW DISPLAYS AWARDS AND RECOGNITION FOR THE WORK. "T" (TESTIMONIAL) FEATURES THE CLIENT TESTIMONIAL REGARDING THE WORK. AND "C" (CASE STUDY) DETAILS THE RECORDED CASE STUDY ABOUT THE PROJECT, INCLUDING THE SCOPE, PROCESS, AND RESULTS.

EVEN MORE INGENIOUS IS NVISION'S MULTIMEDIA PORTFOLIO. THE FIRM WANTED TO MAKE VIEWING ITS PORTFOLIO FUN, SO IT CREATED A PORTFOLIO THAT PLAYS LIKE A GAME. THE MULTIMEDIA PORTFOLIO GAME ALSO FUNCTIONS IN SHOCKWAVE ON NVISION'S WEB SITE.

NStorm is a patent-pending process that drives millions of hits to clients' web sites. NStorm combines the client's message with the fun of email games, and then lets the natural course of email exchange distribute the message to potentially millions of prospective customers. By developing short, entertaining, and engaging games that can be forwarded via email, NStorm allows its customers to send out messages that propagate themselves.

Although the firm is now best known for it's CD-ROM and web site designs, samples of traditional design work are available in a special section of the site. Pieces on display include magazine covers, product catalogs, brochures, and corporate identity work. The black background enhances the design pieces.

NVision Design is a design studio offering web development, graphic design, and multimedia design. The corporate identity is carried over to NVD's web site by use of primarily olive green, black and white, and the company logo.

This enhanced brochure was created for Taylor Publishing,
one of the largest yearbook publishers in the United States
providing complete yearbook services to elementary, junior
high, and high schools as well as colleges since 1939.
Taylor Publishing decided to refresh its marketing messages
by implementing a consistent, contemporary attitude, a
step conducted by NVision Design. In addition to marketing
pieces and magazines, NVision Design generated a compre-
hensive corporate image brochure, detailing Taylor Publish-
ing's history, products, and services. These animations
show how the pieces fit together as the panels flip by.

CLIENT **Taylor Publishing**
DESIGNER **Dan Ferguson**

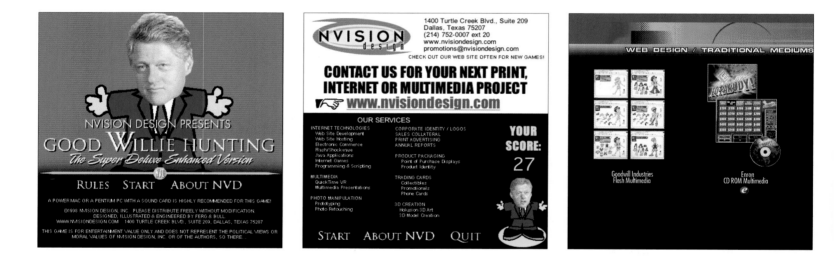

The award-winning NStorm Good Willie Hunting game was released on 1 April 1998. It drove millions of viewers to the NVD site. The "player" is exposed not only to NVision, but to its multimedia work as well by playing the game. Throughout the game, the player is fed information about NVision's many services as well as information on how to contact the firm.

DESIGNER **Dan Ferguson**
PROGRAMMING **Michael Bielinski**

Making the portfolio user-friendly was one of NVision's objectives. Specific instructions and labeled buttons instruct the viewer to the next part of the portfolio by scrolling horizontally, rather than vertically.

Enron Corp. is a natural gas and electric company based out of Houston. NVision developed this CD-ROM multimedia game for the Human Resources Department to train employees on the company benefits. The game "Jeopardy" made learning fun and landed NVision six more CDs for the company.

CLIENT **Enron Corp.**
DESIGNER **Dan Ferguson**
PROGRAMMING **Michael Bielinski**

Hired by TBWA Chiat/Day, an advertising firm, NVision was charged with keeping the corporate identity consistent for UD Trucks, part of Nissan Diesel. The yellow and black motif was retained, along with the logo design.

CLIENT **Nissan Diesel America & TBWA Chiat/Day**
DESIGNER **Dan Ferguson**
WEB SITE DEVELOPER **Dax Davis**
INTEGRATOR **Steven Davis**
PROGRAMMER **Jacob Cameron**

This web site was created for Assa Abloy, an industrial lock company in Europe. The purpose of the site was to show off the product line, which includes many types of locks and lockers, and to allow ordering via the Internet.

CLIENT **Assa Abloy**
DESIGNER **Dan Ferguson**
WEB SITE DEVELOPER **Dax Davis**
INTEGRATOR **Jason Eason**
PROGRAMMER **Dax Davis**

MAKE A CONSCIOUS EFFORT TO COMMUNICATE.

SO YOU'VE GOT THEIR ATTENTION. NOW WHAT? WELL, IF YOU WANT TO AVOID FRUSTRATING AND LOSING THEM, PRESENT YOUR WORK IN A MANNER THAT IS EASY TO UNDERSTAND AND EASY TO OPERATE. IT'S JUST AS IMPORTANT AS WOW-ING YOUR CLIENT.

A GOOD DIGITAL PORTFOLIO IS SELF-EXPLANATORY— YOU PROBABLY WON'T BE THERE TO OFFER DIRECTION. ANTICIPATE THE VIEWER'S CONCERNS, AND DO YOUR BEST TO ELIMINATE ANY POSSIBLE PROBLEMS. EVEN THOUGH POTENTIAL CLIENTS ARE MORE TECHNOLOGICALLY SAVVY THAN EVER, IT DOESN'T MEAN THAT YOUR CREATIVE THOUGHT PROCESS WILL MATCH THEIRS.

YOUR TIME IS VALUABLE. SO IS THEIRS. KEEP THIS IN MIND WITH FAST DOWNLOADS. IF THE DESIGN ENVIRONMENT IS SIMPLE AND UNCLUTTERED, THE VIEWER SHOULD HAVE NO PROBLEM MAKING HER WAY THROUGH IN A TIMELY FASH-ION. IT WOULDN'T BE A BAD IDEA TO FACILITATE DOWN-LOADABLE PLUG-INS SUCH AS SHOCKWAVE, NETSCAPE, QUICKTIME, OR ADOBE ACROBAT READER EITHER.

EASY TO

Copyright Infringement

The web has provided an equal opportunity for designers to display their work around the globe. A designer in the Netherlands, for example, can now easily acquire a client in New York. But this vast technology has its downside. The issue of copyright infringement has heightened as the web has become a new design medium. The Digital Millennium Copyright Act of 1998 clarified issues about computer-related work and extended the protection provided by copyright. Graphics and text that appear on a web site or other digital portfolio are copyright-eligible materials.

Placing an exact copyright statement on a digital portfolio is the first step in combating the problem. If you are working in the international realm, it is wise to state explicit copyright for two reasons. One, other countries require it, and two, it protects against a claim of accidental infringement. Some designers have taken it a step further by imbedding a tagline in all the artwork. Others have created images with watermarks. Still others have used their corporate identity to brand each page of their portfolio. Whatever the approach, it is vital to put some sort of security guard in place to protect yourself as well as your clients.

The issue of copyright infringement of digital work will continue to be a hot topic in the graphic design field for years to come. Those with a lack of creativity will continue to search for ways to duplicate the work of others. Fortunately, there is one glitch with work for the web —72 dpi. Maybe the lament over low-resolution files isn't such a big deal after all!

WHERE DO WE GO FROM HERE? ONE OF THE MOST OBVIOUS WAYS TO MAKE YOUR PORTFOLIO EASY TO OPERATE IS TO EFFECT SIGNPOSTS. DEVELOP A STRONG SUITE OF NAVIGATION SIGNAGE ON THE HOME PAGE. TELL THE VIEWER WHERE TO GO. LABEL THE BUTTONS WITH ICONS OR WORDS. AND BE CONSISTENT WITH THE BUTTONS. DON'T CHANGE THE LOCATION, SHAPE, OR COLOR. YOU'LL ONLY CONFUSE. MANY FEEL IT'S IMPORTANT TO NOT STRAY FROM WHAT HAVE BECOME STANDARD LOCATIONS—NAVIGATION ON THE LEFT, CONTENT ON THE TOP, COMMUNICATION WITH THE COMPANY ON THE BOTTOM.

PROVIDING A NEXUS OF DESIGN WORK IS ALSO A TIME-SAVER. IT ALLOWS THE POTENTIAL CLIENT TO HONE IN ON A PARTICULAR TYPE OF WORK, AND SKIP CATEGORIES THAT DON'T APPLY OR INTEREST HIM.

DON'T GO TOO DEEP. MULTIPLE LEVELS WILL CAUSE IRRETRIEVABLE CONFUSION. DRILL IT DOWN SO THE POTENTIAL CLIENT IS NEVER MORE THAN TWO CLICKS FROM HOME PAGE. DON'T GET THE VIEWER LOST. YOU DON'T WANT ANY PANIC ATTACKS OR, WORSE, LOST ACCOUNTS.

Finally, don't go overboard. Use technology to your advantage without compromising your design skills or taste. A digital portfolio represents a dichotomy. On the one hand, it's a medium for showing your skills and imagination. On the flip side, it's a communication tool. One can't function without the other. Just like you can't function without a client.

PLANET DESIGN COMPANY

WITH PLANET DESIGN'S DIGITAL PORTFOLIO, THE FIRM WANT-
ED TO HOUSE ITS SAMPLES IN SOMETHING THAT WAS INTER-
ESTING BUT AT THE SAME TIME DIDN'T OVERSHADOW THE
WORK. KEEPING THAT IN MIND, PLANET DESIGN DEVELOPED
A VERY BOLD, BUT SIMPLE LOOK. THE COLORS AND TYPE
USED THROUGHOUT ARE AN EXTENSION OF THE PLANET
CORPORATE IDENTITY. PLANET DESIGN STRONGLY BELIEVES
IN CONSISTENCY ACROSS VARIOUS MEDIA AND THE DIGITAL
REALM SHOULD BE NO DIFFERENT. ITS GOAL WAS TO
PRESENT THINGS AS SIMPLY AS POSSIBLE. THE FIRM WANTED
TO GET POTENTIAL CLIENTS INTERESTED IN THE WORK, NOT
IN THE WAY IT'S PRESENTED. AS AN ADDED PLUS, ON THE
WEB, A SIMPLE PRESENTATION IS A FAST PRESENTATION.
PLANET DESIGN DIDN'T WANT TO TAKE UP PEOPLE'S TIME
UNNECESSARILY.

The opening page is an extension of Planet Design
Company's identity. The company colors and typeface
are consistent throughout. By clicking on the logo,
the viewer is able to enter the digital portfolio.

Planet Design wanted the client to be able to view
its portfolio with as little difficulty as possible.
To make the site user-friendly, downloadable plug-ins
are available so the viewer can experience all the bells
and whistles.

In order for a potential client to get acquainted with Planet Design, the Method page gives an insight into how Planet Design ticks. The firm strives for a clear strategy, getting to the soul of the company or product, maintaining consistent communication, and following through.

The Planet Design portfolio can be reviewed in two different ways: either by industry or by type of work.

The "type of work" the firm has done includes annuals and books, logos and identity, packaging, advertising, direct mail, and new media. Clients are listed under each category along with the location—city and state.

Planet Design's portfolio is available in two formats: virtual and real. If the potential client is interested in seeing a "real" portfolio, he can click on the [REAL] briefcase for instructions.

This 1999 Product Catalog was part of the effort to redirect Rollerblade's brand personality and image. Planet Design was responsible for all phases of the campaign, including national ads, product catalogs, brochures, merchandising, and corporate identity.

CLIENT **Rollerblade, Inc.**
CREATIVE DIRECTOR **Dana Lytle, John Besmer**
ART DIRECTOR **Dana Lytle**
DESIGNER **Jamie Karlin**
WRITERS **John Besmer, Seth Gordon**
PHOTOGRAPHY **Image Studios – Steve Eliasen and Michael Leschesin**

Viewers can take a logo tour by clicking on the Work page left-hand column. Featured are logos for a wide spectrum of clients, including production companies, restaurants, outdoor signage, hair salons, publishing companies, and communications firms.

CLIENT **Brave World Productions**
CREATIVE DIRECTOR **Kevin Wade**
DESIGNER **Dan Ibara**

The Flick section of the digital portfolio directs potential clients to Planet Design's work in motion graphics and television. This section was designed to wow the viewer with the firm's technical prowess.

ITCH MOTION GRAPHICS

Itch is a pilot for a music-based TV show featuring unsigned bands. The title sequence juxtaposes clean white lettering with brilliantly colored, unfocused backgrounds. The frenetic soundtrack (composed and produced by Planet), consisting of scurrying-insect clicks overlayed with a sibilant pulse, is intended to conjure up the under-the-skin itch musicians feel to pursue their art. In the final frames, everything fades except the "Itch," which remains flickering like a bad fluorescent tube.

[DOWNLOAD]

© 1997 PLANET DESIGN COMPANY
160 X 120 QUICKTIME 1.9 MB

Itch Motion Graphics is a pilot for a music-based tele-
vision show featuring unsigned bands. Planet Design
produced the pilot as well as composed and produced
the accompanying soundtrack.

CLIENT **Itch Motion Graphics**
CREATIVE DIRECTOR **Kevin Wade**
DESIGNERS **Martha Graettinger, Kevin Wade**

ASYLUM GRAPHIC DESIGN

ASYLUM GRAPHIC DESIGN TRIED TO MAKE THE DESIGN OF IT'S WEB PORTFOLIO AS SIMPLE AS POSSIBLE. THERE ARE VERY FEW LINKS, MAKING THE SITE SIMPLE TO NAVIGATE. THE IDEA WAS TO SHOW AS MUCH AS POSSIBLE IN A LITTLE AMOUNT OF TIME TO KEEP CLIENTS INTERESTED. THE DESIGN MATCHES THE ASYLUM IDENTITY SYSTEM FOR CONSISTENCY. CLIENTS WILL RECOGNIZE THE COLORS AND DESIGNS IN ITS BROCHURES AND OTHER CORPORATE LITERATURE. THE FONTS ARE SIMPLE SAN SERIFS. THE BLACK-AND-WHITE SITE DESIGN KEEPS THE ENVIRONMENT AS SIMPLE AS POSSIBLE SO CLIENTS CAN SEE THE FULL-COLOR WORK CLEARLY. FEEDBACK HAS BEEN GREAT—THE FIRM HAS RECEIVED MUCH MORE BUSINESS OFF THIS WEB PORTFOLIO, COMPARED TO ITS PREVIOUS ONE, WHICH REQUIRED MUCH MORE EFFORT TO GET AROUND.

Asylum has incorporated interactive elements to remove the static nature of the web when the viewer enters its web portfolio. The tag line—a design communication refuge—appears first, then the company name. Next an eye appears out of a swirl of color, symbolizing vision. There are five different sections describing the company and work it does.

...brings the potential client straight ...phy and correspondence ...hite background with black banner ...ntain the consistency of the site.

The main screen of each section is black with a white box containing the index—an instant table of contents. This index remains on the left of the page at all times to facilitate looking at other design pieces quickly without paging back and forth. This meeting prospectus piece was designed for the Radiological Society of North America.

The identity section features every... identity systems to product logos... system was designed for Clic/On C... The corporate colors of black and... over throughout all the design pie...

CLIENT **Clic/On Communication...**

Clic/On Communications
full identity system

Andersen Consulting
meeting logo

Océ-USA
product logo

Jaster
corporate logo

JASTER inc.

**Radiological Society of
North America**
meeting logo

The background was changed to white in order to
view this product logo for Océ-USA more clearly.
This logo is for Océ Smart Track, a network printing
cost recovery system. The colors, orange, blue, and
black, are an extension of the company identity.

CLIENT **Océ-USA**

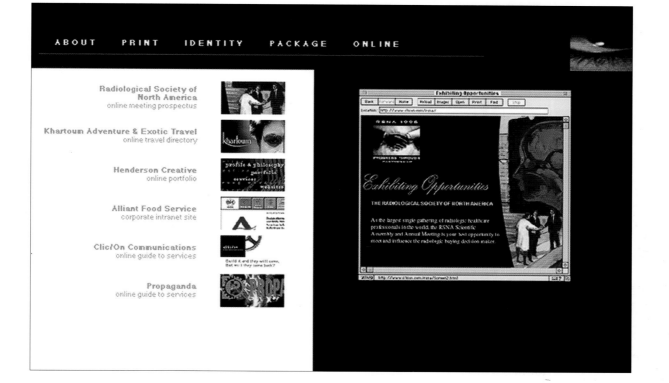

ABOUT PRINT IDENTITY PACKAGE ONLINE

Radiological Society of
North America
online meeting prospectus

Khartoum Adventure & Exotic Travel
online travel directory

Henderson Creative
online portfolio

Alliant Food Service
corporate intranet site

Clic/On Communications
online guide to services

Propaganda
online guide to services

This online meeting prospectus was designed for the
Radiological Society of North America. The site fea-
tures a mostly black background with a shot of a skull
in red on the right. The images include hands shaking
and a group conversing, stressing the importance of
communication.

CLIENT **Radiological Society of North America**

SCOTT HULL ASSOCIATES

SCOTT HULL ASSOCIATES IS AN ILLUSTRATOR REPRESENTATIVE FIRM THAT FOCUSES ON DEVELOPING ARTIST-CLIENT RELATIONSHIPS. HULL LOOKS FOR EDGY ILLUSTRATORS WHO KEEP UP WITH THE TIMES AND CHANGE ACCORDINGLY. THE WEB PORTFOLIO USES LITTLE CUT-AND-PASTED CHARACTERS TO CREATE A BRANDED LOOK. KEEPING A FUNKY, YET CONTEMPORARY FEEL, THESE CHARACTERS ARE ENHANCED WITH VIVID RED, BLACK, AND WHITE BACKGROUNDS. THE FONTS SEEM PRETTY BLAND UNTIL THEY ARE REJUVENATED IN THE CUT-AND-PASTE PROCESS OR MADE TO LOOK LIKE HULL'S ACTUAL HANDWRITING.

THE PEEP SHOW IS ACTUALLY A PORTFOLIO OF PORTFOLIOS. TWENTY-ONE ILLUSTRATORS ARE FEATURED. A NAVIGATIONAL TOOL IS LOCATED AT THE BOTTOM OF EVERY PAGE. IF YOU WERE LOOKING AT A PARTICULAR ILLUSTRATOR'S PAGE, WITH A CLICK YOU COULD RETURN TO PEEP SHOW. WITH CLEARLY MARKED BUTTONS AND DIRECTIONS, SCOTT HULL ASSOCIATES DEVELOPED AN EASILY NAVIGABLE, ENJOYABLE, AND INFORMATIONAL SITE.

The black background with red and white highlights is an extension of Scott Hull Associates' identity. The firm specializes in representing illustrators.

This square grid home page features wacky pasted characters for categories such as Art in Action, Peep Show, Pass It On, and Hull Notebook. The portfolio section is the Peep Show.

Click on a tile below to see more of that artist's work

The Peep Show page is half black and half white, providing an interesting contrast. The top half in black features an illustration of a Peeping Tom, while the bottom half of the page features thumbnails of the twenty-one illustrators against a white background. By clicking on a tile, the viewer is able to go directly to that illustrator's page.

Each illustrator's page has a selection of five or six thumbnails to choose from, along with an enlarged picture of one of the thumbnails. Carefully labeled instructions tell the viewer to "Click on a thumbnail below to jump directly to that image."

At the bottom of every illustrator's page, there is a bar of buttons instructing the viewer on how to navigate the portfolio. Buttons include "previous," "next," "back" and "home." The "back" button features a mouse character, while the "home" button says "Hull."

PLATINUM DESIGN, INC.

PLATINUM DESIGN'S WEB PORTFOLIO IS SEPARATED INTO SEVEN DESIGN CATEGORIES SO THAT POTENTIAL CLIENTS CAN EASILY AND QUICKLY FIND PROJECTS THAT APPLY TO THEIR SPECIFIC AREA OF INTEREST. THE PERIODIC TABLE OF ELEMENTS SERVES AS THE THEMATIC MODEL FOR THE SITE. THE SCIENCE THEME IS AN INNOVATIVE PLAY OFF THE PLATINUM NAME. THE SITE IS DIVIDED INTO FOUR SEGMENTS: BIOGRAPHY, CLIENT LIST, PORTFOLIO, AND CONTACT PAGE. IN ORDER TO FACILITATE FAST DOWNLOADING, PLATINUM'S WEB PORTFOLIO MAKES SELECTIVE USE OF ANIMATION AND PHOTOGRAPHY. A THREE-COLOR (PLUS BLACK) PALETTE IS USED THROUGHOUT THE SITE FOR FAST LOADING AND TO SUGGEST A 1950s SCIENCE TEXTBOOK THEME. THE SITE USES SAN SERIF FONTS (SYNTAX, STONE SANS), WHICH ARE CLEAR AND EASY TO READ. THE IMAGERY IS SOPHISTICATED, YET CLEAN, ALLOWING FOR EASY NAVIGATION.

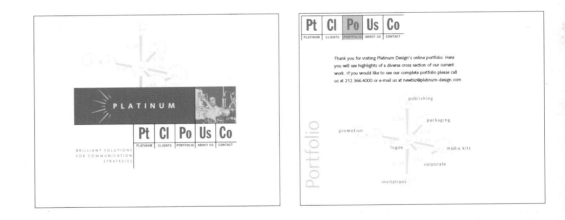

One of the potential problems for clients viewing design work on the web is the time it can take to download images. Platinum Design curtailed the download time by keeping the color selection simple and the images clean in its electronic portfolio.

WEB SITE DESIGN
ART DIRECTOR/DESIGNER **Kelly Hogg**
CREATIVE DIRECTOR **Vickie Peslak**
PROGRAMMER **Alec Cove**
PHOTOGRAPHY **Paul Lachenauer**

The molecular structure of the portfolio section plays off the Platinum name. Categories include Publishing, Packaging, Promotion, Logos, Media Kits, Corporate, and Invitations.

COHESIVE DESIGN CAPTURES READER'S ATTENTION

When this non-profit arts and literary publication was interested in upgrading its visuals and reducing their oversized format, Platinum's extensive editorial experience was put to good use. Our challenge with this redesign was sophisticating the appearance of the copy heavy publication and creating a visually appealing, reader friendly design without sacrificing the content of its editorial. Platinum designed a flexible grid system, incorporated a two-color design theme and bolder graphics to appeal to a wider market. By using tight crops and silhouettes, strong color and photo manipulation, Platinum was able to create dynamic images from black and white press shots. Changing the paper stock and color of the creative writing section was a cost-effective and tactile way to immediately distinguish it from Bomb's editorial pages and other magazines of its kind.

kgrounds of the various sections are orange
ception of the logo section. This helps
e design work on display without competing
sign. Thumbnails on a square grid can be
ith a click of the mouse for better viewing.

Platinum was enlisted to do a complete redesign for *Bomb Magazine*, a non-profit arts and literary publication. The firm incorporated a flexible grid system and a two-color design theme. Bolder graphics were used to appeal to a wider market.

CLIENT **Bomb Magazine**
DESIGNERS **Mike Joyce, Kelly Hogg**

THE PACKAGE IS PART OF THE ADVENTURE

The Mobius Award recognizes the highest level of achievement in package design. This CD package created by Platinum, was singled out for this honor. QIN, an epic adventure game, explores the subterranean tomb of China's first emperor. We captured the essence and adventure of this interactive game by echoing its atmosphere, helping to make this CD one of the top 10 sellers in its genre.

The navigation bar is clearly marked throughout the site. There are no mystery buttons or confusing image mapping. At the bottom of each index page is a bar of categories for other sections of the site, including the portfolio index page, allowing for easy exits and entries.

QIN is an electronic epic adventure game th explores the subterranean tomb of China's f or. Developed for Time Warner Electronic Pu this package received the Mobius Award, th level of achievement in package design.

CLIENT **Time Warner Electronic Publishin**
ART DIRECTION & DESIGN **Kathleen Phelp**

NEWSLETTER ENHANCES PUBLIC IMAGE

To strengthen its image in the community and to establish a means for regular communication within the Police Department, the New York City Police Foundation selected Platinum Design to develop a quarterly newsletter to be made available in every precinct throughout the five boroughs. We developed regular columns to address ongoing key issues, ensuring a sense of continuity and familiarity for all future issues, and we suggested short, newsy articles, to keep reader interest high. The overall design retains the blue and black of police uniforms within a modern framework of bold headlines, dramatic photos, and inviting copy.

Platinum designed this quarterly newsletter as a pro-
motion for the New York City Police Foundation. It is
made available in every precinct throughout the five
boroughs. The overall design retains the blue and
black of police uniforms within a modern framework
of bold headlines, dramatic photos, and inviting copy.

When it's time for updating, Platinum trades old pro-
jects for new ones and makes copy improvements on
occasion to keep the portfolio fresh. The firm replaces
projects rather than adding them in order to make
changes more easily and to avoid overloading viewers
with too many projects.

CLIENT **New York City Police Foundation**
ART DIRECTION & DESIGN **Kathleen Phelps**

Corporate

SCHLESINGER ASSOCIATES

SHOWTIME NETWORKS

PFIZER INC

K-III MAGAZINE GROUP

HOME | CLIENTS | PORTFOLIO | ABOUT US | CONTACT

Showtime Action Television

Showtime Comedy Television

Showtime Family Television

Showtime Film Festival

Showtime En Español

ocumentaries?
historical?
science fiction?
ers/suspense?
+ adventure?

's the same set of questions. You'd like to share the results with you.

educational/cultural?

introducing

rns?

musicals?

family?

ted recent Hollywood

wave/avant garde?

SHOWTIME NETWORKS
All the Right Moves

Invitations

KWASHA LIPTON GROUP

BMG ENTERTAINMENT

TIME WARNER CITYCABLE

DIFFA

HOME | CLIENTS | PORTFOLIO | ABOUT US | CONTACT

The corporate index carries over the orange background and square grid format. The background changes, however, when a thumbnail is enlarged to a color that enhances the image without clashing.

This Showtime Networks corporate ad was designed to attract cable operators to five new channels. By superimposing the questions posed to consumers on a sea of people, it is implied that Showtime's promise to its buyers stems from real-world research. The blue background enhanced by white and yellow type evokes a feeling of the big screen.

CLIENT **Showtime Networks**
ART DIRECTION & DESIGN **Kathleen Phelps**

The electronic format of a portfolio allows for viewing work in a 3-D format and from different angles. Invitations lend themselves well to viewing in a pixel format for this reason.

This Time Warner CityCable event celebrated the
simultaneous launch of commercial insertion on its
networks. The die-cut shape allows logos to peak out
of the edges when folded. When open, a vivid, 3-D
effect is achieved.

CLIENT **Time Warner CityCable**
ART DIRECTION & DESIGN **Platinum Design, Inc.**

THOUGHTHOUSE, INC.

THE THOUGHTHOUSE, INC., WEB PORTFOLIO IS AN EXCEL-
LENT EXAMPLE OF A USER-FRIENDLY DIGITAL PORTFOLIO.
THE FIRM WANTED TO CREATE A WEB PORTFOLIO THAT HAD
A MULTIMEDIA-CONSOLE FEEL WITH AN INDUSTRIAL STYLE.
THE CONTROLS NEVER MOVE AND THE "SCREEN" IS WHERE
ALL THE ACTION HAPPENS. THE FIRM'S GOAL WAS TO HAVE
THE USER SCROLL AS LITTLE AS POSSIBLE AND TO BE ONLY
TWO CLICKS FROM THE HOME PAGE AT ANY ONE TIME.

TO ENSURE QUICK DOWNLOAD, THOUGHTHOUSE CHOSE A
PRIMARILY BLACK-AND-WHITE LOOK FOR THE INTERFACE,
USING COLORS ONLY WHEN BUTTONS WERE USED OR ROLLED
OVER. THESE ARE SCALED TO ONE PIXEL ON THE HOME PAGE
SO THEY PRELOAD BEFORE THE USER GOES THROUGH THE
REST OF THE SITE. THE MAIN TYPEFACE USED IS MATRIX.

BESIDES BEING USER-FRIENDLY, THE SITE IS VERY ATTRAC-
TIVE, USING A CURVE FORMAT INSTEAD OF THE MORE POPU-
LAR LINEAR STRUCTURE. THERE IS AN ORGANIC FEEL TO IT,
WITH HOT COLORS AND LOTS OF WHITE SPACE.

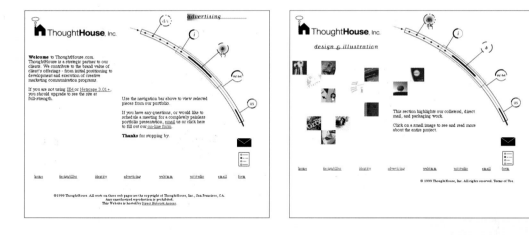

ThoughtHouse makes use of a curve format for its web portfolio. The primarily black-and-white look for the interface allows for quick download time. Sections are clearly marked at the bottom of the page.

The design and illustration section (d/i) shows square thumbnails of collateral, direct mail, and packaging work. Once a viewer clicks on a thumbnail, a larger view, along with a description of the project, appears.

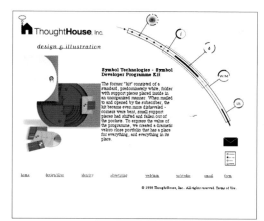

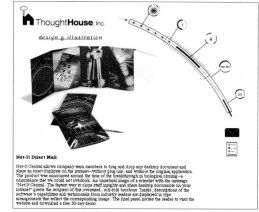

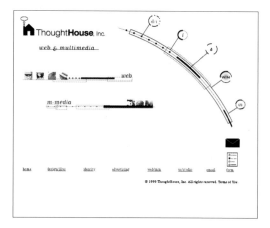

ThoughtHouse developed a dramatic Velcro close port-folio for Symbol Technologies' programme kit so that there was a place for everything and everything was in place when it arrived to a subscriber.

CLIENT **Symbol Technologies, San Jose**
DESIGNER **Carrie English**
PHOTOGRAPHY **Robert Sondgroth**

Net-It Direct Mail software allows duplicates of desk-top documents to be shared on the Intranet without plug-ins or the original application. ThoughtHouse played off the clone theme in designing this piece.

CLIENT **Net-It Software (now called Allegis)**
DESIGNER **Ken Roberts**
PHOTOGRAPHY **Stock (Tony Stone)**

The web and multimedia page offers animated thumb-nails to exhibit the firm's prowess in web and multi-media design.

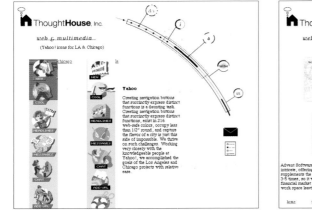

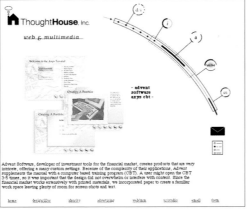

ThoughtHouse created web site navigation buttons for Yahoo's Los Angeles and Chicago sites. The buttons are colorful and enticing, and the pictures express well what they represent.

CLIENT **Yahoo!**
DESIGNER **Carrie English**

ThoughtHouse designed a computer-based training program to support Advent Software's investment software program manual.

CLIENT **Advent Software**
DESIGNERS **Carrie English, Ken Roberts**

The advertising page features thumbnails of complete advertising campaigns as well as web banners.

ThoughtHouse, Inc.

advertising

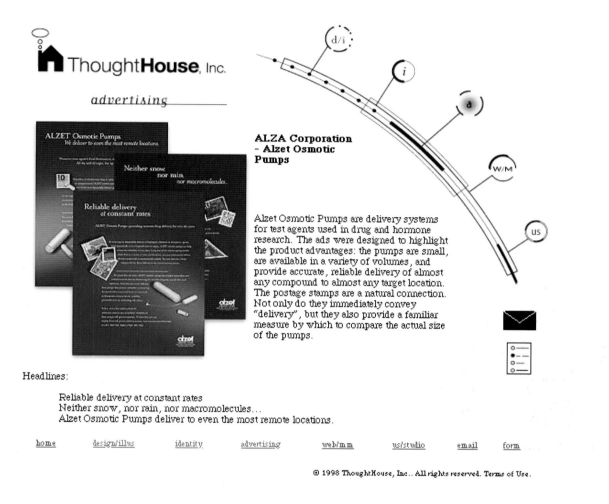

**ALZA Corporation
- Alzet Osmotic
Pumps**

Alzet Osmotic Pumps are delivery systems for test agents used in drug and hormone research. The ads were designed to highlight the product advantages: the pumps are small, are available in a variety of volumes, and provide accurate, reliable delivery of almost any compound to almost any target location. The postage stamps are a natural connection. Not only do they immediately convey "delivery", but they also provide a familiar measure by which to compare the actual size of the pumps.

Headlines:

Reliable delivery at constant rates
Neither snow, nor rain, nor macromolecules...
Alzet Osmotic Pumps deliver to even the most remote locations.

home design/illus identity advertising web/mm us/studio email form

EASY TO OPERATE

ThoughtHouse used postage stamps to demonstrate just how small Alzet Osmotic Pumps are. The pumps provide accurate, reliable delivery of almost any compound to almost any target location. They are used extensively in drug and hormone research.

CLIENT **Alza Corporation**
PHOTOGRAPHER **Robert Sondgroth**

INDEX OF DESIGNERS

NVision Design, Inc.
1400 Turtle Creek Blvd. Ste. 209
Dallas, TX 75207
U.S.A.
214-752-0007
Web: www.nvisiondesign.com

Oh Boy, A Design Company
49 Geary Street, Ste. 530
San Francisco, CA 94108
U.S.A.
415-834-9063
Web: www.ohboyco.com

Planet Design Company
605 Williamson St.
Madison, WI 53703
U.S.A.
608-256-0000
Web: www.planetdesign.com

Platinum Design, Inc.
14 West 23rd St.
New York, NY 10010
U.S.A.
212-366-4000
Fax: 212-366-4046
Web: www.platinum-design.com

Richard Puder Design Group
2 W. Blackwell St., P.O. Box 1520
Dover, NJ 07802-1520
U.S.A.
973-361-1310
Web: www.strongtype.com

Scott Hull Associates
68 E. Franklin St.
Dayton, OH 45459
U.S.A.
937-433-8383
Web: www.scotthull.com

Skolos-Wedell, Inc.
529 Main Street
Charleston, MA 02129
U.S.A.
617-242-5179
Web: www.skolos-wedell.com

The Swish Group Limited
502 Albert Street
East Melbourne
Victoria 3002
Australia
613 9662 1233
Fax: 613 9663 8805
Web: www.swish.com.au

ThoughtHouse
944 Market Street, Ste. 500
San Francisco, CA 94102
U.S.A.
415-773-0555
Web: www.thoughthouse.com

Web Presence Networking, LLC (Expidant)
950 N. Merididian St., Ste 920
Indianapolis, IN 46204
U.S.A.
800-750-0047
Web: www.web-presence.com

Yamamoto Moss
252 First Avenue North
Minneapolis, MN 55401
U.S.A.
612-375-0180
Web: www.yamamotomoss.com

INDEX OF CLIENTS

ACKNOWLEDGMENTS

I am deeply grateful for those at Rockport Publishing who offered me the challenge of writing this book. Up at the top of the list is my editor, Jack Savage, who helped make this book a reality through his steadfast encouragement and belief in my abilities.

I would also like to thank Lisa Baggerman of Chronicle Books for leading me to some of the innovative graphic designers and illustrators featured in the book.

Particular thanks goes to the many graphic designers, who without their time and efforts, this book would not have been possible. They include: Dana Lytle and John Besmer, Planet Design; Richard Puder, RPD Group; Joel Nakamura; Bill Current, Asylum; Jan Craige-Singer, Big Blue Dot; Charlie Hill; Robert Dietz, Dietz Design; Grant Jerding; Dan Ferguson, NVision Design; Chaz

Maviyane-Davies, Maviyane Project; Ken Roberts, ThoughtHouse, Inc.; Maura Keller and Christy Nesja, Yamamoto Moss; Steve MacLaughlin, Web Presence Networking (now Expidant); Frank EE Grubich, Laughing Dog Creative; John Barton, Internet Broadcasting Systems; Lisa Mann, Platinum Design; Todd Gimlin, Greteman Group; João Machado and Joana Leão, João Machado Design; Mark Minelli, Minelli Design; Ross Viator, Oh Boy Co.; Phil Scaramozzino, DreamLight Studios; Scott Hull, Scott Hull Associates; Wayne Rankin, The Swish Group; Patrice Eilts-Job and John Storey, EAT Inc.; Nancy Skolos, Skolos-Wedell; and Joel Goldfoot, The Hiebing Group.

Finally, I'd like to thank my employer, GUILD.com and boss Katie Kazan for allowing me to take the time I needed to complete this special project.

Anne T. McKenna

AUTHOR BIO

Anne T. McKenna is a writer and editor who lives in Madison, Wisconsin. She holds an M.A. in Journalism from California State University Fullerton. McKenna has authored a number of educational children's books on subjects such as race cars, snowboarding, inline skating, and mountain peaks. McKenna served as acquisitions editor for MBI Publishing Co., a mid-sized specialty book publisher that is part of the Chronicle Publishing group. McKenna has also been a staff writer for a West Coast boating magazine and an editor for a professional industry magazine. Currently, McKenna is the Editorial Manager for GUILD Publishing, a publishing imprint of the GUILD.com web site.

CD-ROM OPERATING INSTRUCTIONS

ABOUT THE DIGITAL PORTFOLIO CD-ROM
The CD-ROM that accompanies this book is an interactive resource showcasing the site projects presented in the Graphic Designer's Digital Portfolio book.

BEFORE OPENING THE CD-ROM
Be sure to turn off virtual memory. Set your monitor's color depth to 8-bit (256 colors). The CD-ROM will not run properly otherwise.

The CD-ROM features links to each of the URLs presented in the Graphic Designer's Digital Portfolio book, as well as more than two hundred additional typography related URLs.

To connect directly from the CD-ROM follow the "Linking to the Web" instructions below.

TO PLAY THE CD-ROM
On MacOS systems

Open the Graphic Designer's Digital Portfolio folder on the CD-ROM. Double-click the "WWTYPE" icon and have fun. The "Help" button located on each screen will show you how to navigate the interface.

For more Web-design software links, check out the "Type Resources" section on page 184 or open the CD-ROM and check out the Web sites area for more cutting edge URLs.

On Windows systems

Choose "RUN" from the File menu. Type: (the letter of your CD drive) i.e. D:\WWTYPE.EXE and then click "OK." The "Help" button located on each screen will show you how to navigate the interface.

LINKING TO THE WEB
To connect to the Graphic Designer's Digital Portfolio CD-ROM Web sites you need an Internet connection through an Internet Service Provider. To connect to the Web from the CD-ROM open your Internet connection by starting up your browser the same as if you were going on the Web.

Once you are connected to your provider, open the CD-ROM and choose the Web project you would like to view.

If you would like to have access to all of the Web sites at once, open the Graphic Designer's Digital Portfolio home page bookmark file in the main folder of the CD-ROM.